The Artist's

SAFARI

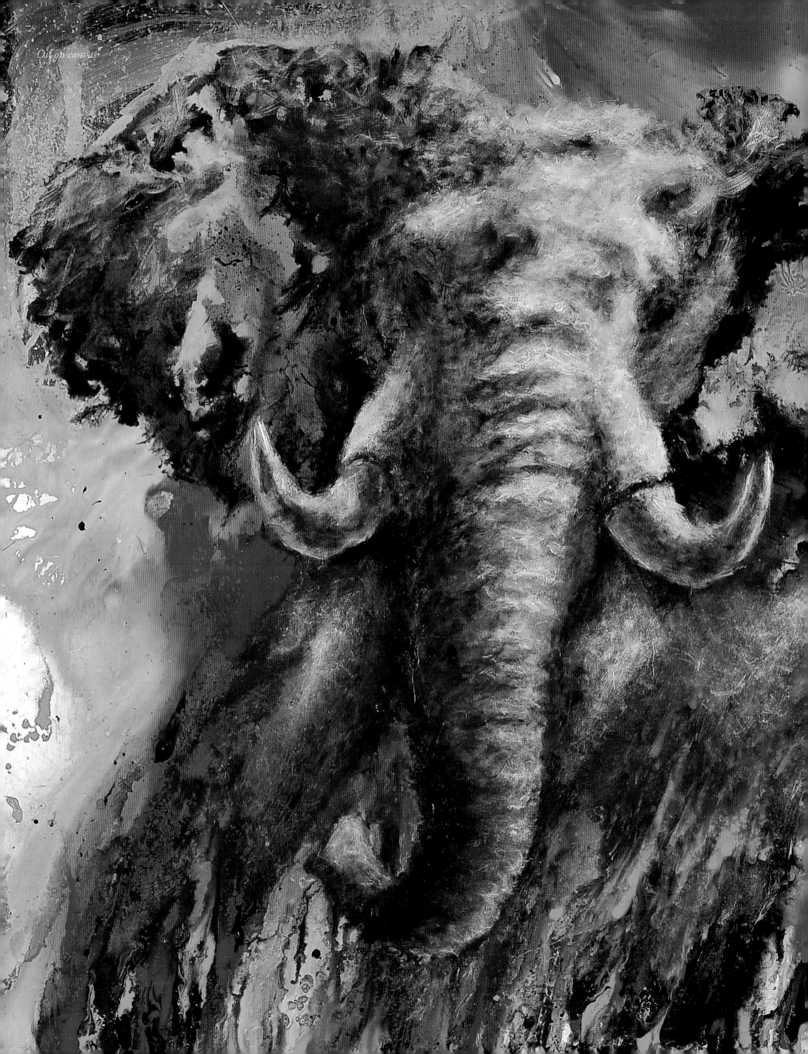

The Artist's
SAFARI

Capturing Africa
with
Pen, Lens, and Paintbrush

FRED KRAKOWIAK

with Barbara Toombs

FOREWORD BY DR. LAURIE MARKER, DPHIL,
Founder/Exective Director of the Cheetah Conservation Fund

MAVERICK BRUSH STROKES
Scottsdale, Arizona

Published by Maverick Brush Strokes, LLC
11914 East La Posada Circle
Scottsdale, AZ 85255
Tel: (602) 376-5431
www.maverickbrushstrokes.com

BookStudio

Produced by BookStudio, LLC
www.bookstudiobooks.com

Contributing Writer BarbaraToombs
Edited by Karla Olson, BookStudio
Copyedited by Lisa Wolff
Designed by Charles McStravick, Artichoke Design
Index by Ken Della Penta

ISBN: 978-0-9787084-1-2 (hardcover)

Publisher's Cataloging in Publication Data

Krakowiak, Fred.

The artist's safari : capturing Africa with pen, lens, and paintbrush / Fred Krakowiak
with Barbara Toombs. -- Scottsdale, Ariz. : Maverick Brush Strokes, c2012.

p. ; cm.

ISBN: 978-0-9787084-1-2
A continuation of the authors' "Africa: an artist's safari" published by Maverick
Brush Strokes in 2007.
Includes bibliographical references and index.
Summary: An artist's sketchbook of stories and paintings of his travels in Africa.
Highlights the endangerment of the wild animals and their intricate ecosystems, and
the importance of working together to save them and the culture of wild Africa.

1. Krakowiak, Fred--Travel--Africa. 2. Wildlife art--Africa. 3. Safaris--Africa-
-Pictorial works. 4. Animals in art. 5. Africa--In art. 6. Africa--Description and travel.
7. Wildlife conservation--Africa. 8. Artists' books. 9. Artists' writings. 10. Artists'
tools. I. Toombs, Barbara. II. Krakowiak, Fred. Africa: an artist's safari. III. Title.

PRINTED IN CHINA BY EVERBEST PRINTING, LTD

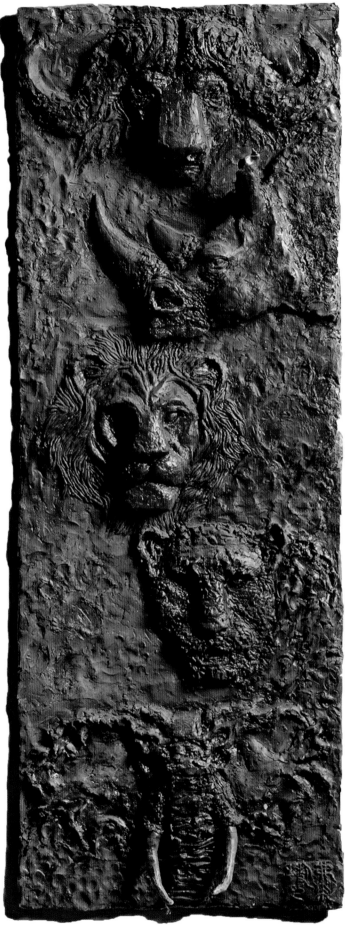

Bronze, "Big Five"

Contents

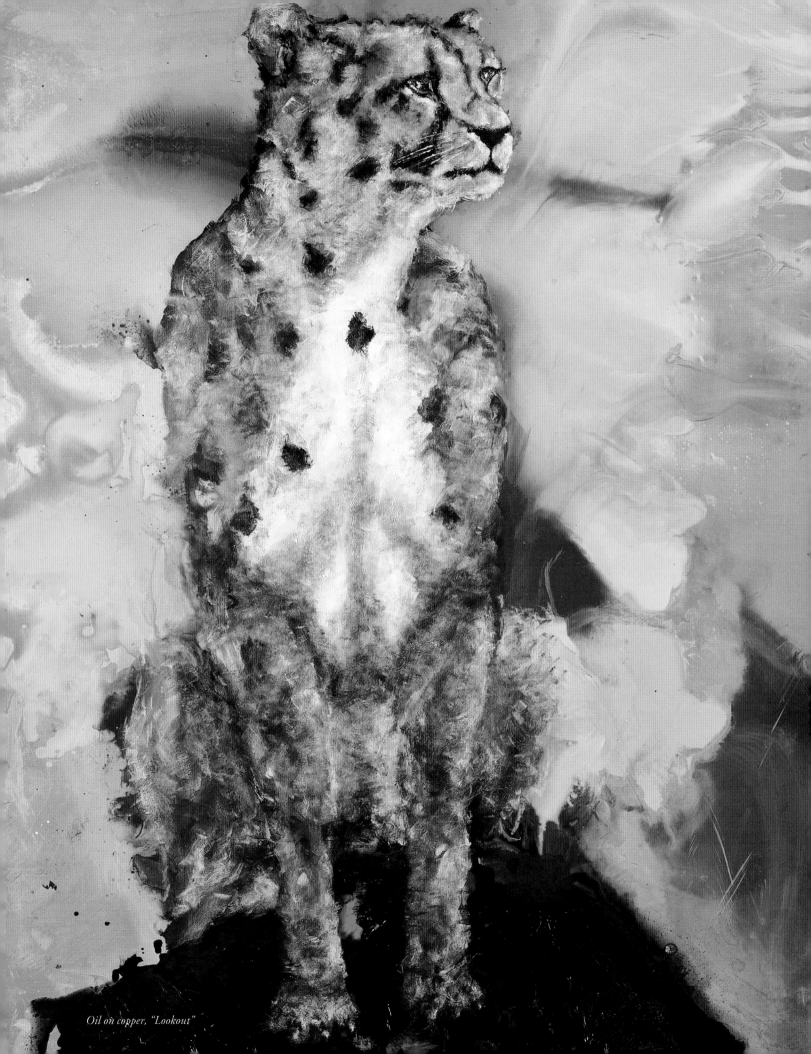

Oil on copper, "Lookout"

CONSERVATION OF OUR AMAZING PLANET AND ALL THE life forms on it is a job that belongs to every human being. I have learned this firsthand during the 21 years since I founded and have led the Cheetah Conservation Fund (CCF)'s efforts in Namibia, a country that houses nearly one third of the ca. 10,000 wild cheetahs still left in this world. Were it not for the involvement of government, community, and most importantly, the livestock farmers who share the land with Africa's most endangered cat, our efforts on behalf of the wild cheetah would not be as successful as they are in stabilizing the wild cheetah population of Namibia.

Fred Krakowiak's safari stories in the African bush take the reader to a land that is magical for its richness in wildlife and that millions dream of seeing during their lifetime. They also demonstrate that Fred knows the importance of education; for we cannot love what we do not understand. And educate he does!

The Artist's Safari, through beautiful prose and amazing images, establishes an intimate link between the reader and the awesome animals that face certain extinction without human protection. He reminds us of the important role that humans play in conservation, as we are directly affected by any losses within the perfect mechanism that is Nature.

Many people fear predators, especially big cats such as the cougar, cheetah, and leopard. We are often taught to fear them without understanding their unique behaviors, special adaptations, and essential roles in the maintenance of healthy ecosystems. Fred's stories put predators in a different light, as they make the reader realize that the absence of carnivores would result in large and unhealthy populations of prey animals, which in turn would greatly contribute to the desertification of an already thirsty earth. Fred reminds us that the cheetah's survival, and that of other wildlife, depends on people and our ability to manage the wild population and protect its habitat.

To quote an often-used phrase, "extinction is forever," and indeed it is. My hope is that *The Artist's Safari* will take the reader on a magical trip through the wilderness of Africa, while instilling in everyone the desire to conserve that magic so that our children, and our children's children, will never have to ask us why we didn't do enough to stop extinction.

LAURIE MARKER, DPHIL
Founder and Executive Director, Cheetah Conservation Fund
www.cheetah.org

"I shut my eyes to see."

—PAUL GAUGUIN

It is said that once you visit, Africa will always be a part of you. Truer words have never been spoken. Although many years have passed, I need only to shut my eyes to see, with all my senses, my first night in Africa—the hippo's deep bellow echoing down the Zambezi River valley; the screeching fish eagles climbing into the sky, about to mate; the coarse twine-like bark of the enormous baobab tree; the sweet scent of the African bush as dusk settles over the plains; the sight of my first elephant, its enormous gray bulk moving with surprising silence through the savannah.

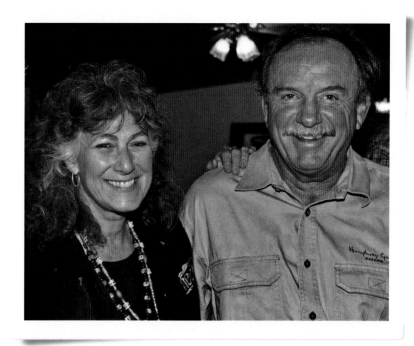

Dr. Laurie Marker and the author

Since that night I have returned to Africa many times, and my heart is still not satisfied; I understand that it probably never will be. Each time I visit, I learn a little more about the people and wildlife who inhabit this unique corner of the globe, I become more intoxicated with the unscripted adventures of the magnificent animals I encounter, and I leave a little more of myself in this magical part of the Earth.

Close encounters with the amazing creatures of Africa allow me to look deep into their souls and capture their spirits with pen, lens, and paintbrush. My heart beats even harder when I shut my eyes and remember my reflection in their stares. I am humbled by the gifts they offer by allowing me to witness their instinctual fight for survival. I am driven to paint because I know they are in a battle for their existence.

The statistics are appalling. Fifty years ago there were 450,000 lions in the wild; today there are 20,000. Where once 700,000 leopards roamed, today only 50,000 exist. The cheetah once numbered 100,000 back in the early 1900s; today some 10,000 of these beautiful cats remain. These sad numbers, as well as the animals' magnificence, motivate me to honor the dignity and beauty of these superb creatures by capturing them in my sketchbook and on canvas, copper, and silk. It is my passion—my calling, if you will—and my gift to Africa.

When you're on safari, you never know how the day will unfold. I have learned better here than anywhere to expect the unexpected, to go with the offerings of the day, to live in the moment, to leave assumptions behind and embrace the very essence of life itself. As I watch the animals in the wild push themselves to just *live* another day, so too have I learned to challenge myself to be the best I can be in every single moment. These are lessons that can be learned only here in Africa, where nature is distilled to its essence, where the air is clearer, the sky is bluer, and a human feels smaller and humbler than anywhere else on Earth.

The pages that follow are colorful threads of life on safari, drawn from my own memories and those of my guides, teachers, and friends Humphrey Gumpo and Mark Ivy, and copied from my sketchbook and camera lens. Together they form a brilliant tapestry emblazoned with life on this exceptional continent. As you move through the pages, I encourage you to value and respect the animals for the amazing creatures they are. Allow yourself to feel humbled by them. Listen to their wisdom. Strive to hear the language they speak, the messages they communicate about the magnificence and frailty of life.

Shut your eyes to see.

Zambezi
River

Rukomechi

Murhani

Long
Pool

Vundu

Chickwenya
Island

Chickwenya

Ryamakusi

Mussina

Sapi
Crossing

Sapi Road

trip
0° South
59° East

MANA POOLS

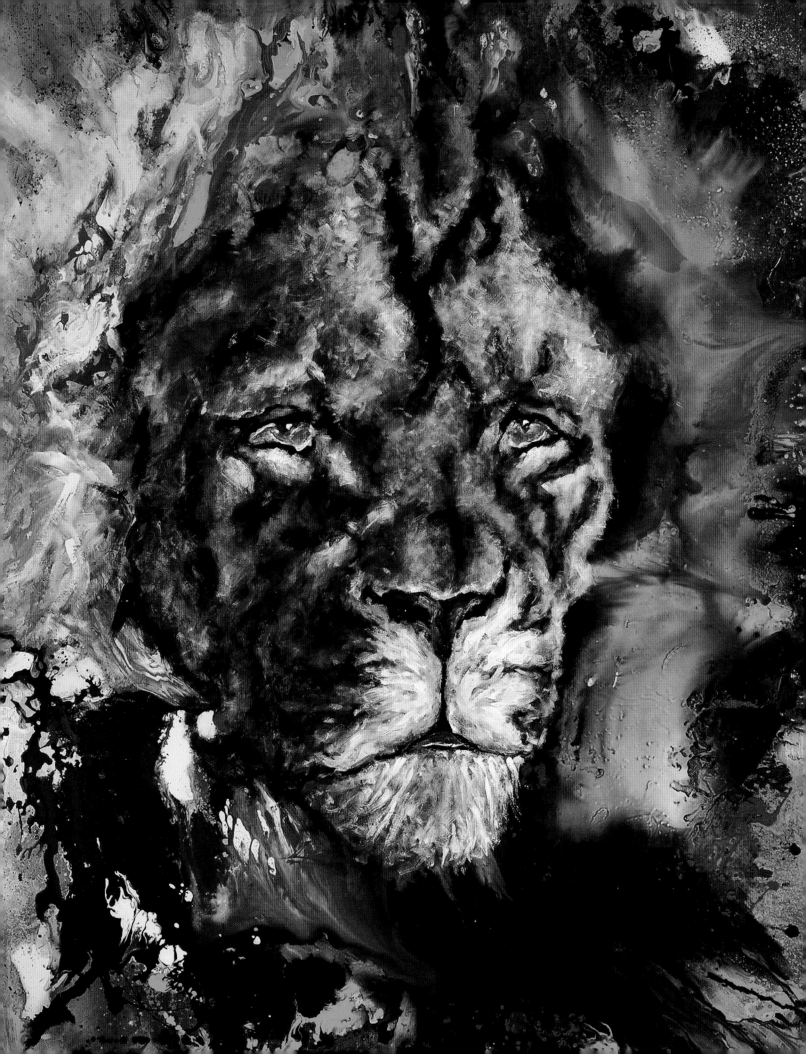

1

The Circle
of Life

IT IS COOLER IN THE THICK, GREEN COPSE

than on the open savannah. Thin beams of golden sun-

light break through the dense foliage, creating a dappled

effect of light and shadow and almost camouflaging the

female giraffe standing before us.

She has left her herd and sought solitude for a reason: she is about to

give birth. After carrying her young one in her womb for over 400 days,

Left: Oil on copper

Oil on copper

this moment is no doubt a welcome one. She has picked a peaceful, quiet spot; the only noise is the occasional stomping of her hooves as she struggles to find a comfortable position. She stands with her hind legs splayed, and before long we watch her tail go up. The time has come.

It feels odd that she utters no sound as she pushes; if she is in pain, she gives no outward show of it. She stares ahead with large, gentle eyes as small hooves come into view underneath her raised tail. Skinny little forelegs follow the hooves, and then we get a glimpse of the baby's head, covered in a slimy embryonic sac. The birthing process seems to stall at this point, with the patient mother-to-be perhaps stopping to rest from her silent exertion. The baby's legs and head dangle, six feet (two meters) above the ground, for what seems an eternity. We hold our breath as we wait for what's about to happen.

At last it comes. After she gives one mighty heave, a tangled, slippery six-foot mass crashes to the ground with a loud, ominous thud. The tall grass hides the baby from our view, and we continue to hold our breath, as we are sure it hasn't survived that brutal drop. But the mother bends, and it becomes apparent that she is licking the afterbirth off her young one. Finally we breathe again as we watch the baby raise its wobbly head and gaze out at his strange, new world. His mother continues to lick him clean, and nudges him repeatedly. Finally, the little giraffe struggles to his feet, takes his first tentative steps, and,

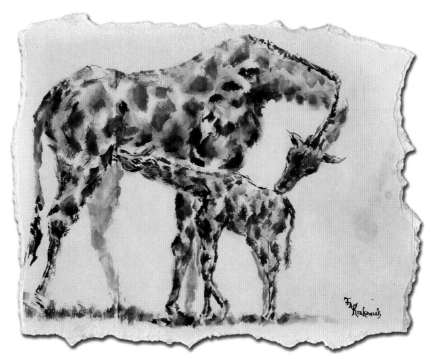

Sumi on rice paper

staying close to his mother's side, follows her off into the distance, presumably back to the herd. He's been in this world less than 90 minutes.

The next few weeks will be incredibly dangerous for this vulnerable guy; only 25 to 50 percent of giraffe calves reach adulthood, often falling prey to lions, leopards, hyenas, or wild dogs. Once giraffes reach adulthood, however, they have little to fear, with only one predator brave enough to risk an angry giraffe's powerful—and often deadly—kick: the lion.

On another fine African venture, lions roaring throughout the very early morning hours eventually bring us out of our tents before dawn to huddle around the blazing campfire, which throws bright flickering

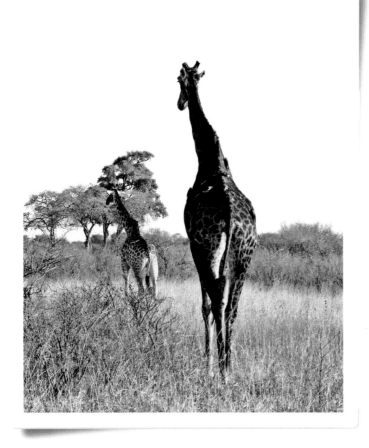

flames of yellow flecked with scarlet into the still-dark sky. Mark Ivy, our guide, estimates that the lions are about 100 yards (90 meters) away and decides that at the crack of dawn we should try to find the pride's tracks, and then follow their spoor.

We eat some fresh fruit—oranges and bananas—stock our backpacks with water bottles and light snacks, and move out to discover today's Africa. But something is strange. Suddenly there are no birds chirping, and even the breeze dies. The silence is deafening. Within a mile from camp, we learn why. We discover a scene right out of the movie *Jurassic Park:* three lionesses in the final stages of taking down a bull giraffe. It is a rare and astounding sight.

The doomed giraffe's coat is crimson, with a random chestnut-brown pattern, and appears blotched on the rear end. I wonder whether this is a sign of fear, happening when the giraffe senses its inevitable fate. The largest lioness leads her pride in the attack, the rising sun causing her coat of orange with dark mustard-yellow highlights to shimmer, emphasizing her bulging back and neck muscles. She squints her eyes, and the skin on her nose ruffles in waves as she clamps down on the giraffe's throat at the nape of its neck, somehow using her weight to pull the massive animal to the ground.

Now, a second, smaller lioness with a deeper-colored coat, tinted burnt sienna and orange, lunges outstretched paws onto the giraffe's hindquarter. Her claws sink into the giraffe's hide, a grasp that clearly cannot be broken. The lioness's forearm muscles gleam in the sunlight and her hind legs hang in midair, a moment that seems frozen in time.

Completing the powerful team, the third lioness leaps above the bull's left foreleg, using her extremely powerful leg muscles to elevate her to the shoulder. Their objective is to knock the giraffe off balance and to the ground, which is no easy task. The stalking lions must have cornered this bull giraffe in a position when he had no escape—in all likelihood, with his front legs awkwardly splayed as he bent to drink, when a giraffe is most vulnerable. The bull is forced to defend his life while Africa watches quietly, knowing the inevitable end.

We have apparently just missed the initial attacks and are now catching the deadly last scene. Mark rationalizes that most likely the lions' primary attack came from the rear in an effort to elude forceful foreleg kicks, which can kill or permanently disable instantly. The lions would have struck repeatedly, wearing down the giraffe until they were able to haul it to the ground. Once they achieve that feat, the advantage goes to the lions. Soon the end arrives for this proud, tall, elegant giant 10 times the size of the beasts that brought it down.

But this dramatic death is only the first act of the show, and we position ourselves about 40 yards (37 meters) away to witness the ensuing drama that is the evolution of Africa.

The lionesses are understandably extremely fatigued and breathing heavily from their tremendous exertion. They lie next to their prize and catch their breath, hearts pounding noticeably in their chests, accentuating their muscular physiques. The sun, now high in the sky, causes their coats to glisten in the bright light, alive with color. There is a sweaty sheen on their shoulders, while their underbellies are a darker burnt sienna and yellow ochre. The artist in me notes how cadmium yellow and orange, with a touch of cadmium red, would bring these lionesses to life on a canvas.

Africa is breathing again and teeming with activity. After a short while, the lionesses begin to reap the rewards of their difficult task and fill their bellies. But two very large male lions, standing four feet (1.2 m) plus at the shoulder, the kings of the pride, interrupt the now-subdued scene. The first sports a primrose-yellow mane with red-oxide touches throughout, spilling into a full black coat over the shoulders. One lion is definitely larger, perhaps almost 500 pounds (227 kg), and he approaches the giraffe, lifting his right forearm and slapping at the dead animal's left shoulder blade. As pride protocol demands, when the males approach, the females scatter, allowing the largest male to eat first. Out of the underbrush comes his brother, with an almost identical mane and brilliant golden coat, but certainly not as tall at the shoulder. He

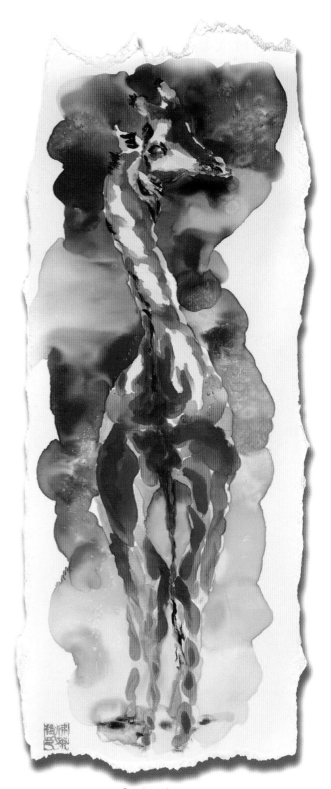

Sumi on rice paper

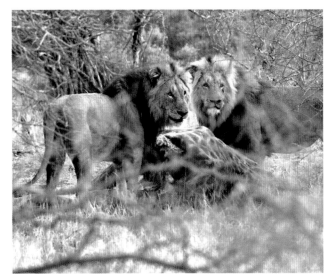

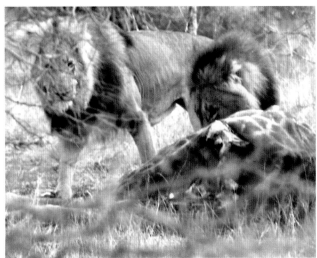

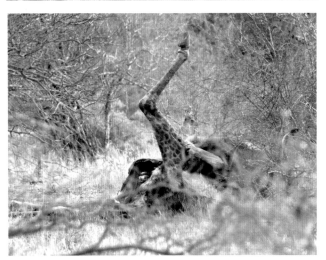

Male lions, Kong and Tag

meanders closer to the kill until he stands at his brother's tail. Within a split second, the larger male, who we name Kong, turns to his right, digging his left foot into the ground to give himself leverage as he stands up. Simultaneously the second male, who we name Tag, braces himself, hind legs square and shoulders caped like the hood of a cobra, his arms poised for the inevitable onslaught from his brother. Kong indeed begins swinging, delivering ferocious blows to both sides of Tag's head and shoulders, until Tag drops to all fours. Kong, relentless, tries to bite his neck, which, fortunately for Tag, is protected by his mane. Nevertheless, Tag receives the message loud and clear: Kong will be the first to eat and get the prime dinner allocations.

Tag moves resignedly to the rear of the giraffe, his frustration evident as his left arm reaches out, his paw slapping the left hindquarter, his claws digging into the giraffe's hide and his forearm muscles bulging like steel cords. He pulls the entire hindquarter of the giraffe into the air, extending the leg to a position perpendicular to the ground in an effort to tip it over and unnerve his brother. We hear the rib cage of the giraffe snap apart, and Kong stops as the giraffe begins to tilt past perpendicular. He raises his head and glares across at Tag as if to say, "Let it go." Tag obediently releases his grip, and the giraffe returns to its lifeless prone position.

The two males work on opposite ends of the giraffe while the three females of the pride reposition themselves in a loose circle just 10 feet (3 m) or so from the giraffe, waiting their turn at the leftovers. They stare at something in our direction, and we realize we are not alone. The sounds of Africa now crescendo. I close my eyes and listen to the leopard vultures, gathering on the limbs of the acacia trees high in the sky. I open my eyes and register their sharp,

four-inch (10 cm) beaks, ready to tear apart the skin of the giraffe's carcass. Also in the trees, Cape vultures, with smaller, two-inch (5 cm) beaks, wait their turn. (Mark tells us that witch doctors of certain tribes eat the Cape vulture, believing the meat will allow them to see into the future—African witchcraft at its finest.) Also waiting patiently in the branches of the acacia are the hooded vultures, usually the last to partake, using their toothpick beaks to pick the bones clean.

I close my eyes again to allow my sense of smell to come alive. The stench I inhale could only be that of the hyena—an odor reminiscent of a urine-soaked woolen blanket. These scavengers, together with another local bandit, the black-back jackals, assemble at a distance.

The fascinating drama continues to unfold, but as dusk approaches we must go back to camp. We have wildebeest stew for dinner and eventually go to bed, but no one can sleep. We end up once again around the blazing campfire, swapping stories and occasionally hearing the roar of the male lions, still busy at their feast.

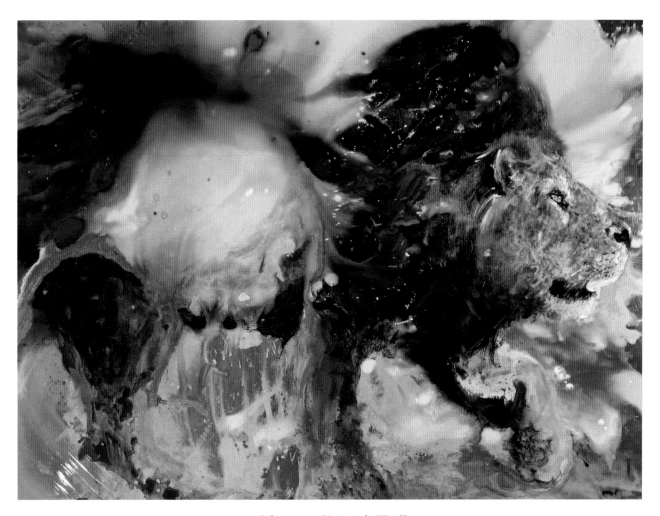

Oil on copper, "Against the Wind"

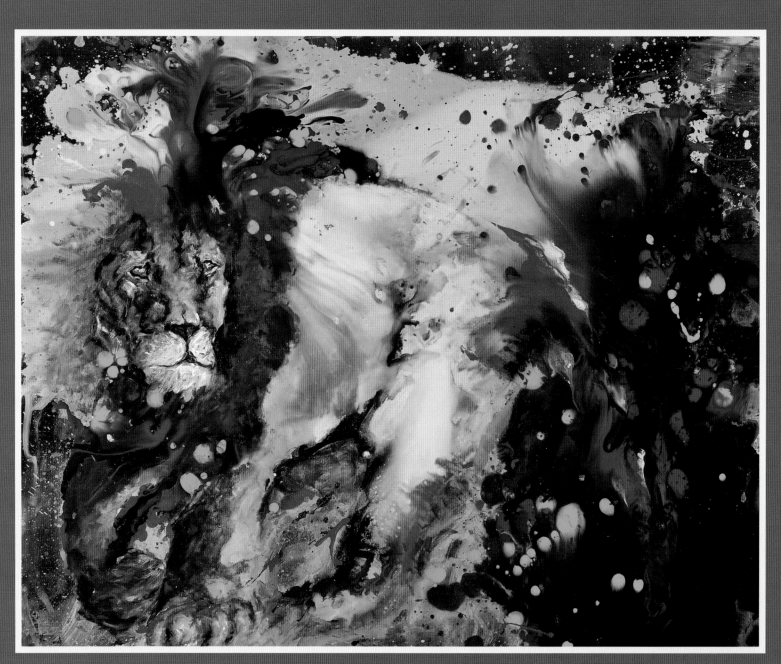

Oil on copper, "Tag"

As the sun rises and the eastern sky turns a brilliant crimson with streaks of lemon yellow, we head back to the kill site. During the night, Kong and Tag filled their bellies, and they now chase the three females, eager for sexual favors. But even with this playful atmosphere, the gathering wildlife does not dare invade the inner circle created by the lion pride, which we now see numbers eight—three females, two males, and three cubs under two years of age with sparkling, horizon-blue eyes.

Early in the afternoon, the large Cape vultures decide to test their luck and sweep down to the carcass, their wings extended. The sudden noise caused by the vultures' oscillating wings reverberates across the distance between the prone giraffe and us. We take in the outstanding view of Africa in motion as the light-on-their-feet vultures spring up and down from the ground to the carcass and back, attempting to steal bits and bites of the feast, while the two male lions make token swipes at the birds. In the not-too-distant background, black-back jackals watch the lions stretch their massive paws into the air in an attempt to bring one of the vultures down. Using the distraction to his advantage, a brave male jackal sneaks in and steals a broken-off rib, and then scampers quickly away.

We return to the scene for a third morning, with still more anticipation. The strong, skunky smell of death in Africa hangs heavily in the air as we come within a quarter mile of the site. When we arrive, vultures and black-back jackals, taunting one another for the scraps, surround the carcass. Today they are joined by a couple of hyena. As the sun rises into the morning sky, the brilliant beams cause four ribs—all that remains of the giraffe's rib cage—to burn a fluorescent fire-engine red blended with blue and yellow hues. We watch for several more hours as the pecking order becomes increasingly disorderly, with the scavengers attempting to steal from one another.

We reluctantly break camp that afternoon, moving on to find another adventure. We are barely three miles (4.8 km) from camp when we come upon a herd of giraffes, and observe a mother stretch her neck down to gently caress her young son. The youngster sits in the grass, head held high and proud, returning his mother's love while several other giraffes forage nearby. Never has the reality of life and death on the African plains felt more real or more poignant.

Page from field sketchbook

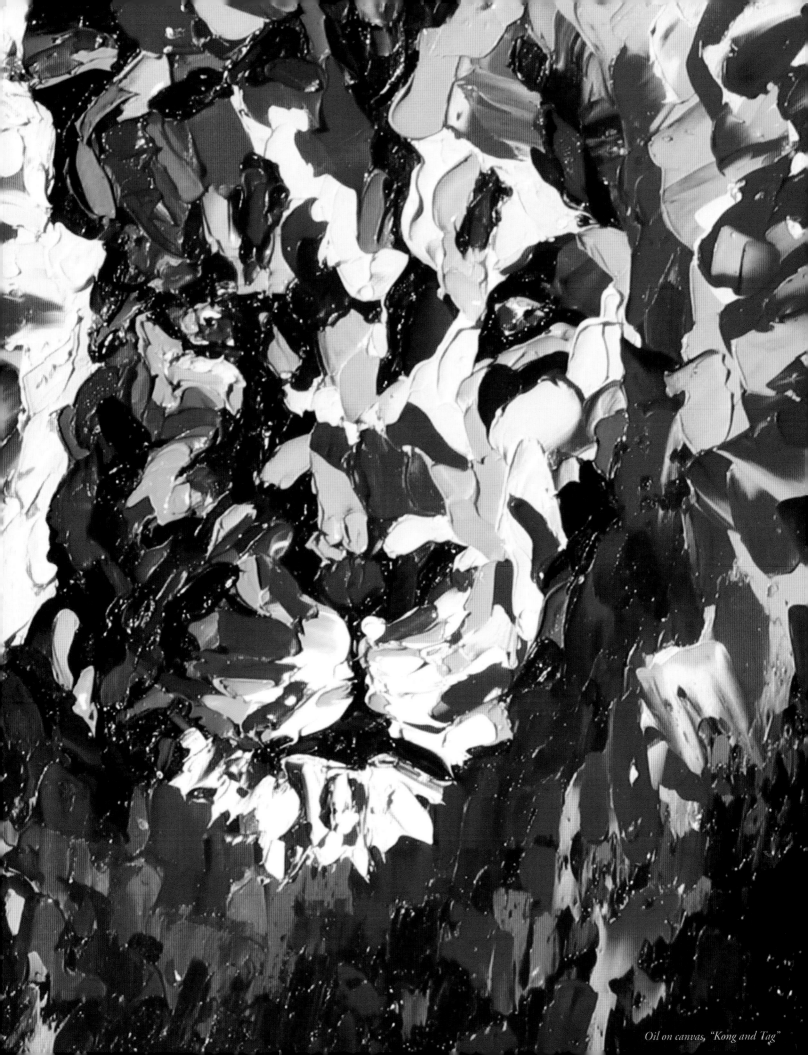

Oil on canvas, "Kong and Tag"

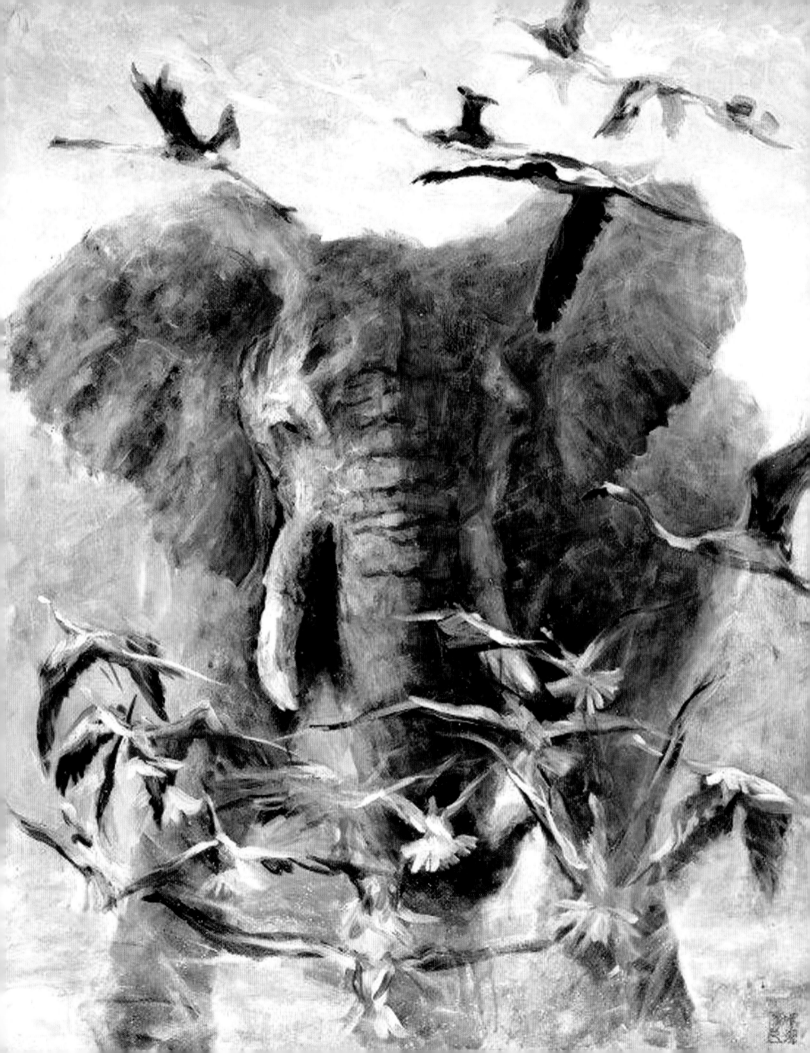

2

Tracking Ivory Carriers

The landlocked country of Zambia derives its name from the Zambezi River, which flows through the country in the west and then forms its southern border with Namibia, Botswana, and Zimbabwe. From here, along the banks of the great river, came the earliest reports of ivory-trade, dating back to the ninth century. The peak of the ivory trade was around the turn of the 20th century, when 800 to 1,000 tons of ivory

Left: Oil on canvas, "Thunder"

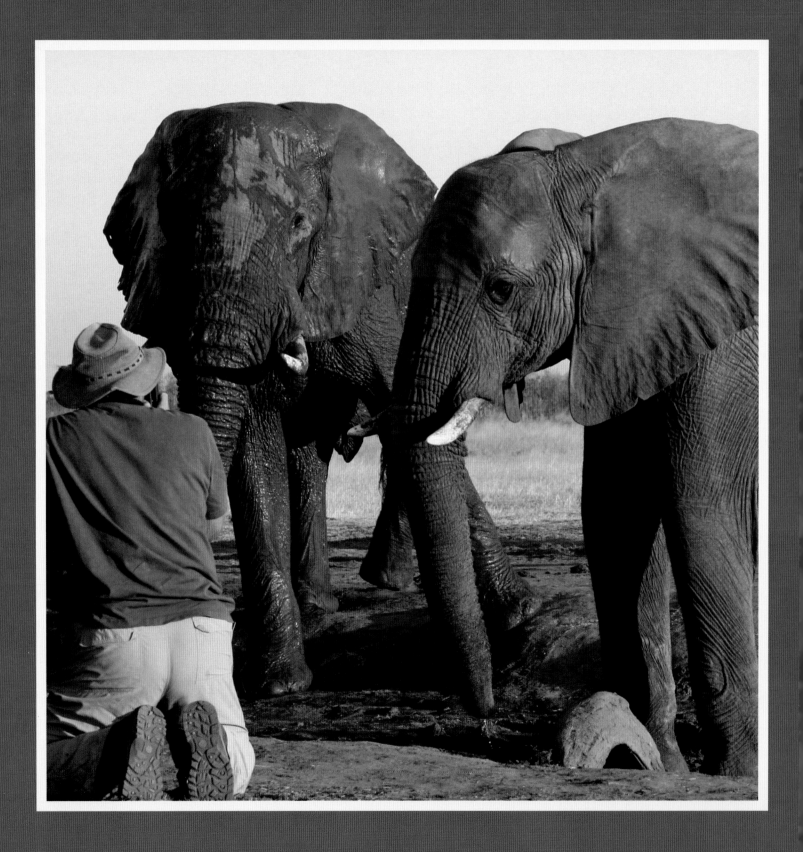

were sent to Europe alone, to be fashioned into piano keys and billiard balls for the entertainment of the privileged elite. It wasn't until 1989 that the Convention on International Trade in Endangered Species (CITES) put a halt to commercial ivory trade.

Our canoes glide silently through the water on another fine African day. We are approaching Chessa point, and there on the steep bank our guide, Humphrey Gumpo, points out one of the few remaining large tuskers along the Zambezi River. This is a rare sight indeed. Elephants with

large tusks are now scarce for a number of reasons, including poaching, but also because professional hunters of the 19th century, in their incessant quest to bag the largest ivory, reduced the gene pool of these tuskers.

After visiting the Elephant Hall Museum at Letaba Restcamp in South Africa's Kruger National Park and seeing the tusks of the famed elephant Shawu—which, when he died at almost 60 years of age, each measured over 10 feet (3 m) in length—I know this spectacular creature on the riverbank is a bull approaching his maturity of 40 years of age, because his tusks are closer to five feet (1.5 m) long. He looks magnificent as he stands on the bank, his tusks gleaming brilliantly in the sunlight. Because the bank is too steep to pull in here, we paddle a bit longer until Humphrey finds us a shoreline where we can park our canoes and go about tracking this tusker.

An elephant's casual pace is about seven miles per hour (11 km), although one can run at almost 30 mph (48 km) for a short burst. Our human jogging pace is probably closer to five miles per hour (8 km), so we had hopes the elephant would be moving toward us or foraging. Humphrey always carries a small container of ash—the lightest environmentally safe substance that will pick up the slightest breeze and keep us aware of the wind's direction at all times. He now tosses some into the air, checking the wind. We are upwind from where we last spotted the tusker, which is good, as he won't smell us.

Nearly all the senses come into play when tracking an elephant. You can usually hear the beast in the thick bush, snapping branches and pushing down small trees when feeding, but when these large mammals walk, they do so almost silently despite their enormous size, because the

outside of the elephant's foot hits the ground before the center of the pad and the noise of the foot hitting the ground is trapped.

Humphrey moves to higher ground now, inspecting the terrain through his binoculars and instructing me to follow directly behind him, warning me that tracking this tusker was going to take patience, persistence, and a little luck. We travel east into the bush, somewhat parallel to the river, for what seems an eternity. Humphrey continually brings his trusty ash container into play to keep us upwind, knowing an elephant not only has excellent hearing, but has such a keen sense of smell it can detect the scent of water from 12 miles (19 km) away.

We stop. Humphrey peruses the landscape and we maneuver back around to the east, being silent as possible, and then pause again, sweating from a mixture of anticipation and anxiety. It is a clear, beautiful day and we can hear the breeze blowing through the trees. Humphrey motions to continue forward, and we quietly advance another 40 yards (37 m) or so. He suddenly holds out his hands and instructs me to stop. The tusker has waded into a channel and is waist high in the water. The sun is shining, throwing light and shadows from the trees into the channel, and there is a brilliant colorful reflection of his tusks glistening on the water's surface.

Today, elephants are more widely hunted with a camera lens than a gun, but the key to getting that once-in-a-lifetime shot hasn't changed for centuries: relying on the skills of an excellent tracker.

Tracking elephants is not difficult when you consider the very size of the footprint, and also ponder the idea that because of the elephant's massive frame it will leave behind traces of its travels, not the least of which is its spoor. An adult male elephant can produce in the vicinity of 220 pounds (100 kg) of dung every day, and its freshness will leave the tracker an indication of how far behind the animal he is.

Humphrey and I crouch down now, crawling onward under the overhanging limbs along the shoreline while the massive elephant continues to reach out with his trunk and gather masses of vegetation, albeit just a fraction of the 300 to 600 pounds (136 to 272 kg) of food he will eat throughout the day. Without warning, the wind shifts and the tusker turns abruptly, staring in our direction. We remain frozen, but to no avail—he has picked up our scent, and now takes several strides toward us with his ears out and trumpets a loud warning for a brief moment before he turns indignantly and heads out of the channel on the opposite side of where we were positioned. Unable to

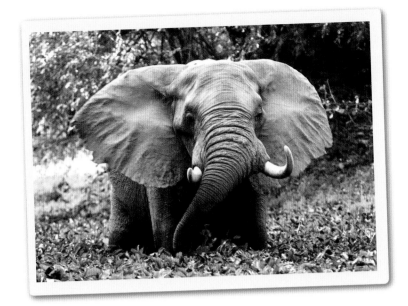

cross the channel at that point, we are forced to go west until we can cross and hopefully pick up his tracks again.

After an hour, we come across a pungent pile of elephant droppings surrounded by a myriad of flies, and subsequently find the tracks of our tusker once again. The search is on. It isn't long before Humphrey lets out a low, bird-like whistle—the recognized bush signal for attention—and there, straight ahead of us, is our tusker, reaching toward the sky for the leaves of an acacia tree. After checking the wind once again, we start running

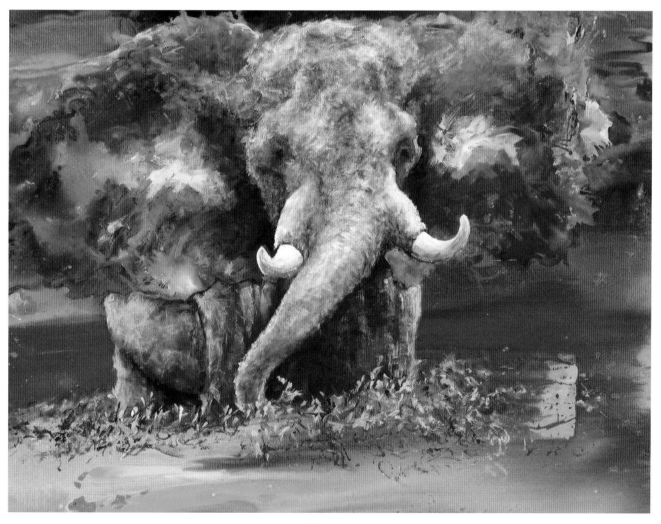

Oil on copper

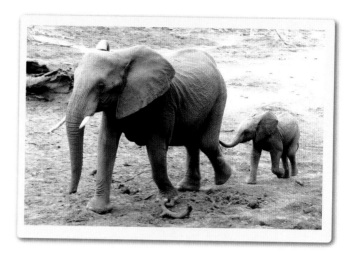

between the ant hills and through combretum scrub, placing our hands on the ground as we move to keep our balance as we scurry along the rough terrain. The underbrush tears at our clothing and we pause behind a patch of "adrenaline grass," golden grass often over seven feet high that is so thick you would almost bump into a buffalo or elephant before seeing it. Humphrey points off to the west and we hear loud cracking: our elephant is snapping off tree branches the size of a man's arm and is clearly foraging on the outer edge of the canopy.

There is no talking whatsoever. Humphrey points to his eyes and then to the elephant, indicating we will get a better view by moving closer, and then bends two fingers and moves them in tandem, indicating that we will crawl. His eyes are on an acacia tree about 30 yards (27 m) away, and our goal is to position ourselves next to the trunk of the tree in order to get a pristine view of this giant up close. Quietly we crawl along the terrain, approaching the base of the tree while our giant friend continues to forage. Unfortunately there is day-old Cape buffalo dung right where we need to position ourselves, but this is no time to be concerned with spoiling our gear. We crawl up and lie down

Tradition of the Totems

Nzoh!" I hear this happy greeting shouted out to me by my friends upon my arrival at the campsite. I smile, for I am humbled each time he calls me an elephant. This is the honorary "totem" given to me a couple of years ago by my Shona and Ndebele friends.

A totem is an animal, plant, or natural object (or symbol of an object) that represents a mystical or ritual bond of unity within a tribe or traditional people. In ancient African times, totems were key symbols of religion and social cohesion and were often the basis for laws and regulations. Today, totems are as scarce as the traditional societies that use them, but in some African societies, such as the one I am visiting today, totems are treasured and preserved for the community's good. Members of the community know it is their duty to protect and defend a totem; many a tale is told in Africa of how men became heroes for rescuing their totems.

In Zimbabwe, totems (known as mitupo) have been in use among the Shona people since the very beginning of their culture. Today, up to 25 different totems can be identified among the Shona, and similar totems exist among other southern African groups, such as the Zulu, the Ndebele, and the Herero.

Out of respect to my friends, my greeting to them is also their totem. Because one of them also has the totem of nzoh, I call him sama nyanga, or "big tusker," so as not to confuse him with myself. My guide Humphrey's totem is the Shona word for leg, or gumbo—very similar to the spelling of his last name, Gumpo. Shoko (monkey), mbada (leopard), and hungwe (fish eagle) are other common totem names in this region.

It is a violation of cultural and spiritual life to hunt, kill, or eat your totem. You share blood with your totem relatives, so to cause injury or death to your totem is tantamount to hurting your ancestors. Totems are highly respected and treasured by my friends, and I feel very honored that they greet me in such a manner.

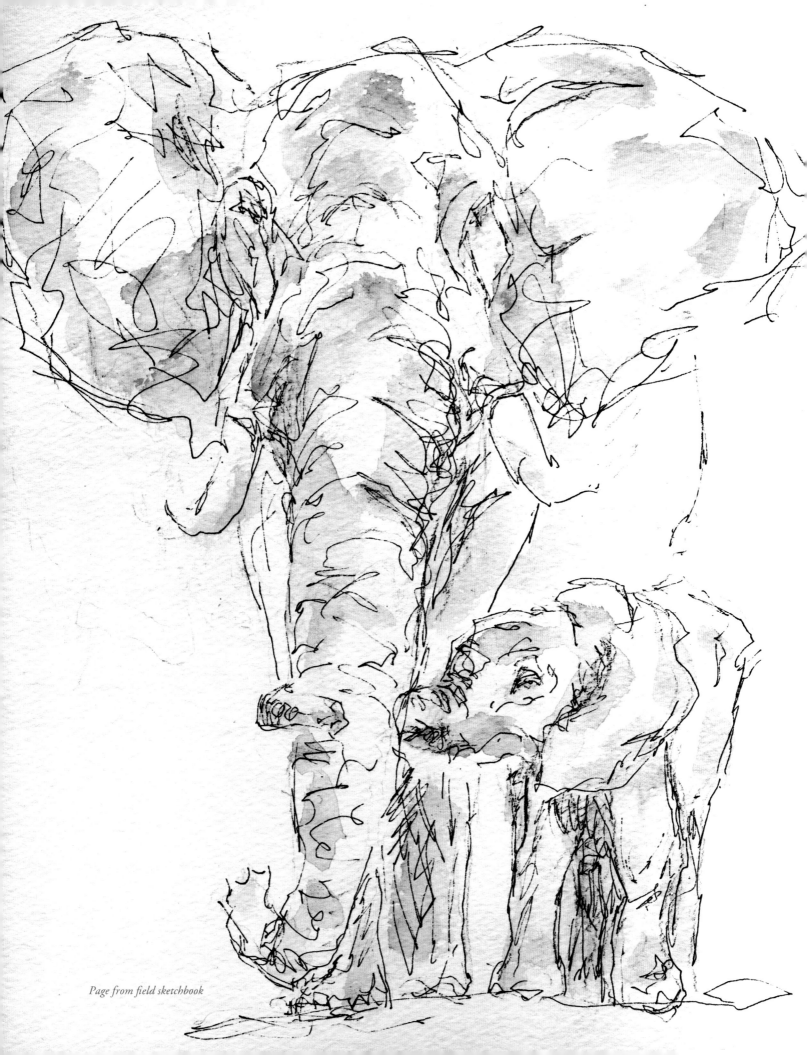

Page from field sketchbook

in the dung. I have my video camera and Humphrey has his still camera; we silently capture the moment and enjoy the serenity, with only the elephant's trunk pulling down the branches of the acacia tree disturbing the silence.

Suddenly the wind shifts, and the tusker turns toward us, moving over the fallen branches and undergrowth with explosions of dirt and brush as the elephant's feet pound the ground with his oncoming charge—ears out and trunk down, coiled into his chest. He trumpets so loudly my spine reverberates and shakes. His head slightly raised, he shows off his large tusks with a beautiful arc, the right one just a little longer than the left. As he approaches, his ears are stretched out, moving forcibly toward our direction. The ears appear torn from the acacia tree thorns ripping away at them as he charges forward. I still cling to my camera, praying it is on. My eye is not on the lens, but rather on this magnificent elephant hurtling toward us.

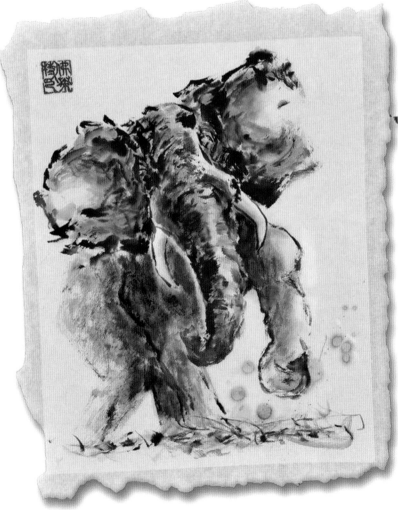

Sumi on rice paper

Humphrey reminds me with hand gestures to remain calm. The right foot of the elephant pounds into the earth four feet (1.2 m) in front of me and then, as my eyes travel heavenward, there are his tusks, thrashing left and right, tearing through the underbrush over my head. His trunk, ripping away at the brush in front of us, intensifies the moment. He sways left and then right, ears waving forward, blocking out the colorful cadmium-yellow beams of the sun, while his eyes glare down at us. The stench of the Cape buffalo dung is suppressed by the rising dust particles exploding toward my face. I raise my head to clear my throat, nose, and eyes—and, with a deep breath, inhale the musky odor of the raging elephant, a smell not unfamiliar to me. As I look up, an enhanced vision of his massive tusks appears; in the shade, the base of the right tusk seems colored a Prussian blue, turning to a crimson red at the tip, but the right side of

the tusk, halfway down, glows a bright ivory white with a touch of lemon yellow where the sun reflected through the tree. His shorter left "working" tusk, half hidden in the shade, has deeper hues of the same Prussian blue and carmine red.

As he thrashes these tusks about, he stirs up the dead leaves and twigs of the underbrush, a crackling ground cover of burnt sienna. The noise of branches breaking is like the sound made by someone crushing a bag of potato chips. He reaches out with his trunk—a subtle Payne's gray with flecks of cobalt blue brought out by the dappled sunlight—seizing a branch in front of me. As he does this,

The sheer size of these magnificent beasts must have been heart-stopping, even to the most fearless professional hunter. Consider, for example, the massive elephant that once bore the largest tusks recorded in Rowland Ward's Records of Big Game: the left tusk weighed in at 232 pounds (105 kg), with a lip-line circumference of 24.5 inches (62 cm) and a length of 10 feet 2.5 inches (3 m); the right tusk 228 pounds (103 kg), with a lip-line circumference of 23.5 inches (60 cm) and a length of 10 feet 5.5 inches (3.2 m). Similar to humans' being right-handed or left-handed, elephants can be either right-tusked or left-tusked. The tusk used more is usually shorter and more rounded at the tip as a result of greater wear; this working tusk is used for bark stripping and food gathering and has a small groove near the tip where the elephant beats the grass to remove dirt. In 1904 one of the largest tuskers on record in Zimbabwe was taken down, carrying tusks that weighed a combined 229 pounds (104 kg) with a circumference of 22 inches (56 cm) at the lip line and a length of nearly eight feet. Truly impressive creatures!

I catch just a glimpse of his rose-violet nostril as he rips the branch and, with a sharp snap, the smell of fresh acacia wood wafts forth. I turn my head toward the ground to avoid getting splinters and dust from the falling leaves in my eyes, and notice the nails of his right foot are worn and chipped, and the skin is cracked. The giant foot seems to take the shape of a mushroom with all of his great weight on it before he lifts it and, without giving notice, simply turns and saunters away. His enormous feet are right at our eye level, and we can see them expanding as they hit the ground in retreat. This old bull is "down at the heel"—a term used by old hunters meaning the footprints are large and from an old bull with big tusks.

Humphrey smiles at me as we lie there, breathless and exuberant, in the Cape buffalo dung. I have the video of my life, and it was recorded in one minute and 42 seconds. To me it was a lifetime.

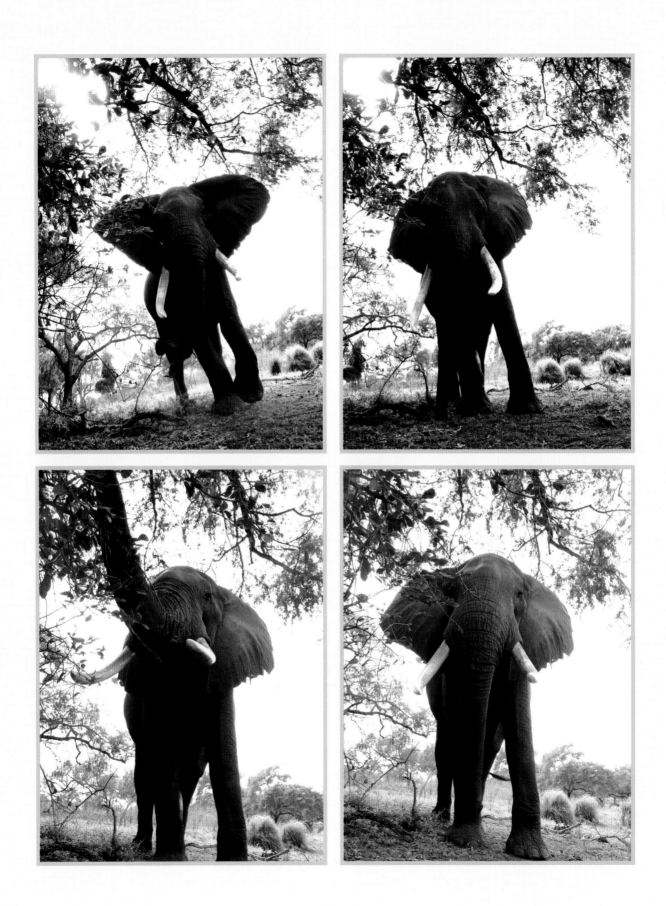

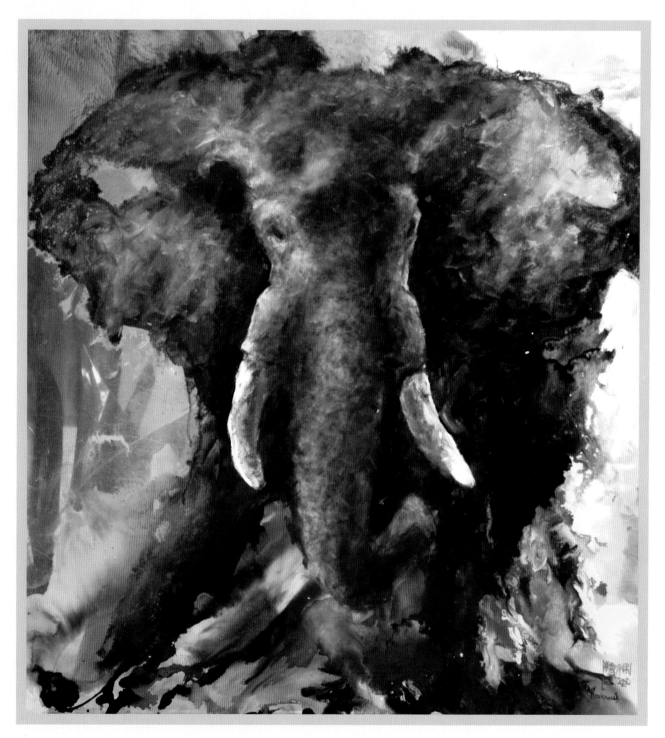

Oil on copper

Tracking Ivory Carriers

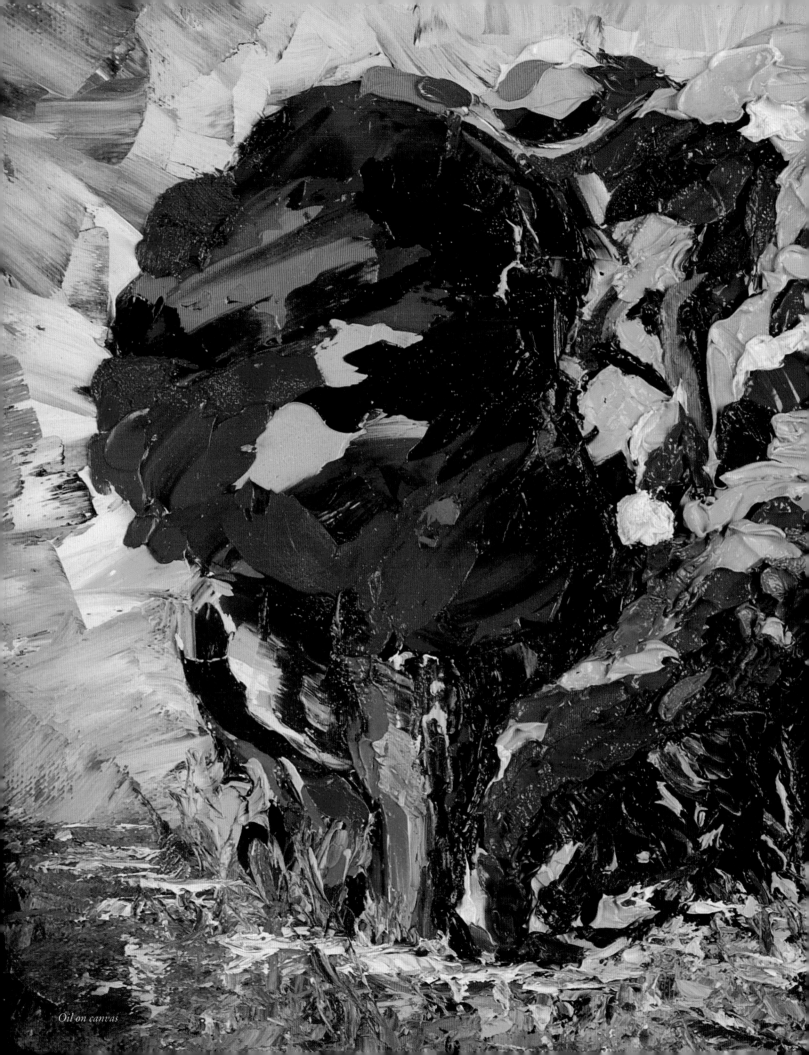

Oil on canvas

3

The Gifts of the African Guides

As EVIDENCED IN THE PREVIOUS TWO

stories, the success of any African safari directly corre-

lates to the expertise of your guide. These gentle, sensi-

tive individuals have a marked pride in their land, the wildlife,

and the people, which is abundantly clear from the moment you meet them.

You will become fast friends with these remarkable people during your time

on the continent, and you will trust them, literally, with your life.

Left: Oil on canvas

Humphrey Gumpo in a baobab tree

Introducing Humphrey Gumpo

Many years have passed since my first days in Africa, but I can still recall my initial introduction—hearing the hippo's deep bellow echoing down the Zambezi River valley and the screeching fish eagles overhead, climbing into the sky about to mate; feeling the coarse, twine-like bark of the enormous baobab tree; and meeting Humphrey Gumpo over a blazing campfire.

My goal on safari has always been to be open to unscripted adventures that provide opportunities of unbridled excitement. To this end, Humphrey continually pushes me to sharpen my knowledge of wildlife, botanical awareness, and tracking skills. He introduces me to points on a map where wildlife retains ownership, where there are no human footprints, and where modern technology has not erased the feeling of mystery.

Walk the land with Humphrey and you uncover the wilderness—the bones of the past—and learn each thread of the intriguing tapestry from which Africa was woven. He is truly a walking museum of knowledge, and exploring the continent with him reveals the land's many fascinating characteristics, especially the struggle for life in the wild.

Humphrey reads Africa the way we read a newspaper. He is a true connoisseur of wildlife, a "whisperer" of sorts, interpreting animals through their posture and the expressions indicated by the shape of their eyes or the position of their ears. I have trusted him with my life many times, including the memorable moment of elephants charging within feet of my body as I lay stretched out on the ground, taking pictures while ivory tusks struck at the underbrush above my head. I am honored Humphrey has allowed me to share the inner circle of magic that Africa offers to those willing to accept its enchantment with open arms and without limitations.

Even at night, Humphrey easily recognizes predators, such as lions, simply by the way they sway their heads, their eye position, and their height off the ground. He analyzes spoor just like a San Bushman, enhancing my knowledge of the bush every day by teaching me the dialect of Africa, testing me regularly. I watch in amazement as Humphrey follows lion spoor or wild dog tracks across ground as hard as solid rock. As a walking guide, he must know the twisting network of trails, how the grass grows in different directions at different times of the year, and which channels of the river to avoid. Like a student gifted in languages, he displays an aptitude for imparting wildlife characteristics and botanical knowledge. He amazes me with his facility with various African dialects, allowing him to communicate with tribesmen whose ancestors date back centuries. His real love, however, is the language of the animals.

Introducing Mark Ivy

A couple of years after meeting Humphrey, I was introduced to a holistic approach to the South African bushveld through the eyes of a guide named Mark Ivy. Walking with Mark in Africa gives you insight not only into wildlife, but into African ecology, history, and culture.

For more than 80 years, the Ivy family has worked in harmony with nature to conserve the diverse African veld. African guides are measured on a scale of one through six, with the remarkable San Bushmen being rated at six-plus. Mark's knowledge and experience put him in the six range. His property in South Africa, Thaba Lodge, consists of more than 8,000 acres—the perfect theater for a lifetime of study that enables him to observe and share the total environment of Africa with others.

Mark's knowledge of veld characteristics is all-encompassing, and while tracking with you, he helps you see and appreciate the ecology of Africa: the different soils, trees, and grasses, together with his expertise on the study of wildlife and animal adaptation.

Interpreting the African bush takes patience and experience. In addition to these two characteristics, Mark has an immense knowledge of the animals and the land, which is not only extremely useful, but pushes me to soak up all the fascinating facts I can glean from him. Take the gemsbok, for example. As Mark and I watch a herd of these elegant animals, he explains that the gemsbok will bypass water to graze because of its internal cooling system, while the wildebeest requires waterholes.

On another day, watching a herd of eland pass by, he teaches me that an individual eland is very difficult to track because of the way it walks. If you listen carefully, you will hear click click pause click click as they walk by; one hoof goes down and then, very often, the second hoof steps into the track of the first hoof. The guide must read not only the shape but the depth of the track to identify this animal.

The Art of Tracking

This is only one indication of the intelligence and intuition required to observe these animals in their habitats. Keep in mind that tracking, stalking, and interpreting the signs of Africa is a slow, laborious process. To learn from elephant dung, for instance, a guide will take a gigantic fresh ball of spoor to camp and check it every hour. How does it dry on a sunny day? How does it dry on a cloudy day? How does the dung react on a misty morning? In addition to the weather conditions, a number of other factors affect elephant dung, including diet, age, and stress. The fresh dung of an elephant—perhaps not surprisingly, considering the vast amount of vegetation it consumes each day—is a deep green, but turns a mottled yellow in about five to six hours on

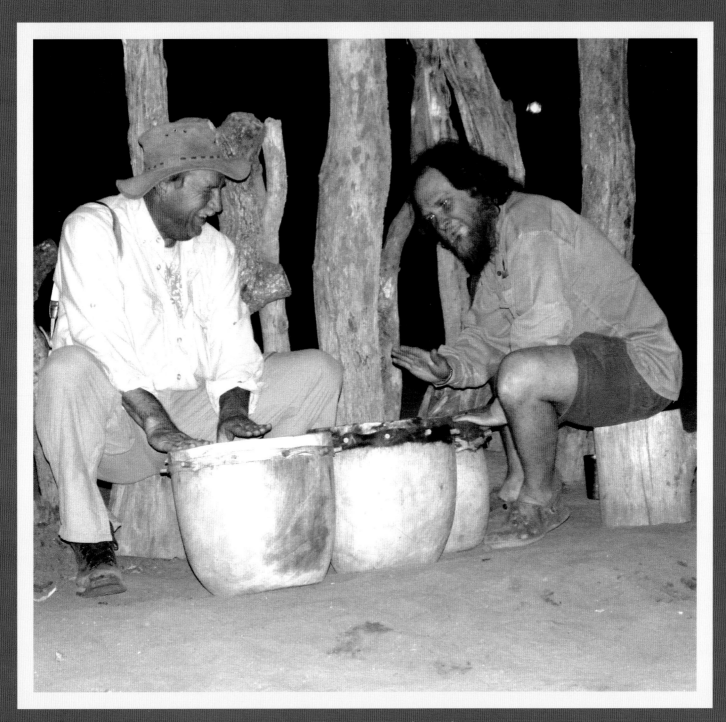

Mark Ivy (right) entertaining our host in a boma

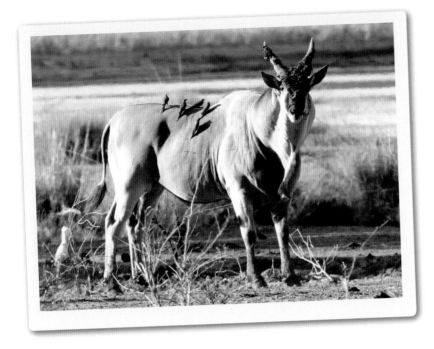

a sunny winter day. On a cloudy day it takes longer.

Wildebeest dung, on the other hand, resembles grapes. In the winter, when water is sparse, the wildebeest retains dung in its colon and literally squeezes water out of it to nourish its body; hence, by the time the spoor hits the ground it is very hard.

Learning tracks, too, is naturally a major part of guide's education. A guide will take the hoof of a zebra and push it into the sand. When a hoof goes down, it pushes all of the sand particles so they are smooth and shiny, and as the day progresses, sand particles fall. But if the wind

Oil on canvas, "Eland on Steroids"

is blowing, sand particles will move and the print becomes rough, which is why the guide will check every hour under different weather conditions. If an animal was running, the print will not be shining smoothly, so the guide must consider the distance between the spoor and what the animal's stride must be.

Surprisingly, even the urine of an animal plays an important role in tracking. Animals that rest at night will have a stronger acidity in their urine in the morning, while those that rest during the day will have a stronger acidity at dusk. Why is this important? The acidity of the urine, combined with how the ground surface absorbs the moisture (sand and dirt absorb moisture differently, so a guide needs to know how the current ground conditions affect moisture absorption), provides a clue as to how long ago the animal was there and how far away it might be.

Although San Bushmen are renowned to be the best trackers, Humphrey and Mark are certainly worthy of superlatives. Tracking through the bush with Humphrey or Mark at my side brings anticipation to an unparalleled level of conscious awareness, one that I have never experienced anywhere else but in Africa.

San Bushmen: Trackers Extraordinaire

The Bushmen tribe of the Zambezi Valley in Zimbabwe are renowned hunters as well as trackers, using the assegai (spear) as well as bow and arrow. The Bushmen learn their skills from an early age; education in the ways of the wild is slow and comes largely from practical experience. They may take the fresh dung of different animals back to their huts and check it every 15 minutes, noting that the dung of every animal behaves differently depending on factors such as the weather and time of year. During the winter, for example, water is sparse and an animal's body will absorb the moisture, meaning their dung will be hard (especially in the case of wildebeest). Urine, too, provides clues to how long ago the animal was at a certain location. The student of the African bush learns this by urinating on different surfaces—sand, dirt, vegetation—and continually watching to see how long it takes these surfaces to absorb the moisture, taking into account the weather and even the wind.

How did the San Bushmen determine what herbs to take if bitten by a deadly cobra? Their ancestors followed the mongoose after it was bitten, observed what it used to cure itself, and then adapted that medicine to aid them if bitten.

These age-old lessons are passed down from tribesman to tribesman and guide to guide, creating the legacy of the African guide.

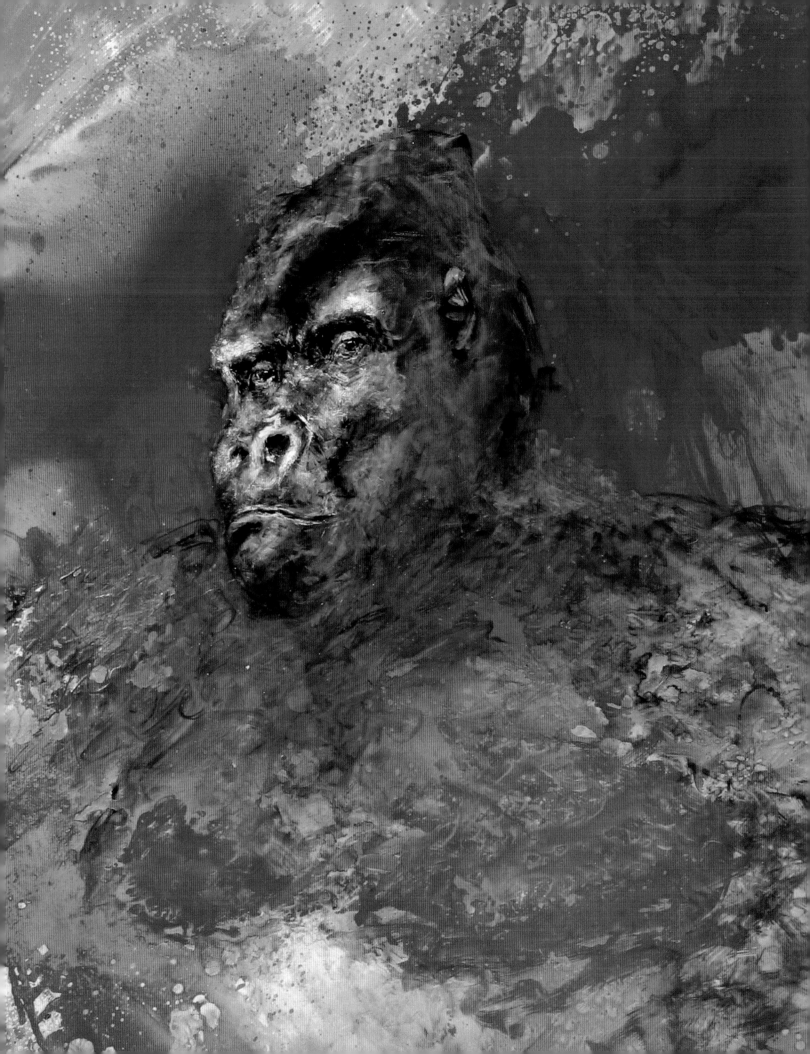

4

Into the
Mist

The forest ahead is so dense that
there are no paths to penetrate its outer boundary. We
are on Mount Karisimbi, one of the eight volcanoes in the
Virunga Mountains of Rwanda's Volcanoes National Park. We care-
fully enter the forest and climb almost vertically on a rocky "trail" about three
feet (1 m) wide, which soon turns into a latticework of foliage. There are hanging
vines and mossy trunks in varying hues of green and viridian. The heavy odor

Left: Oil on copper

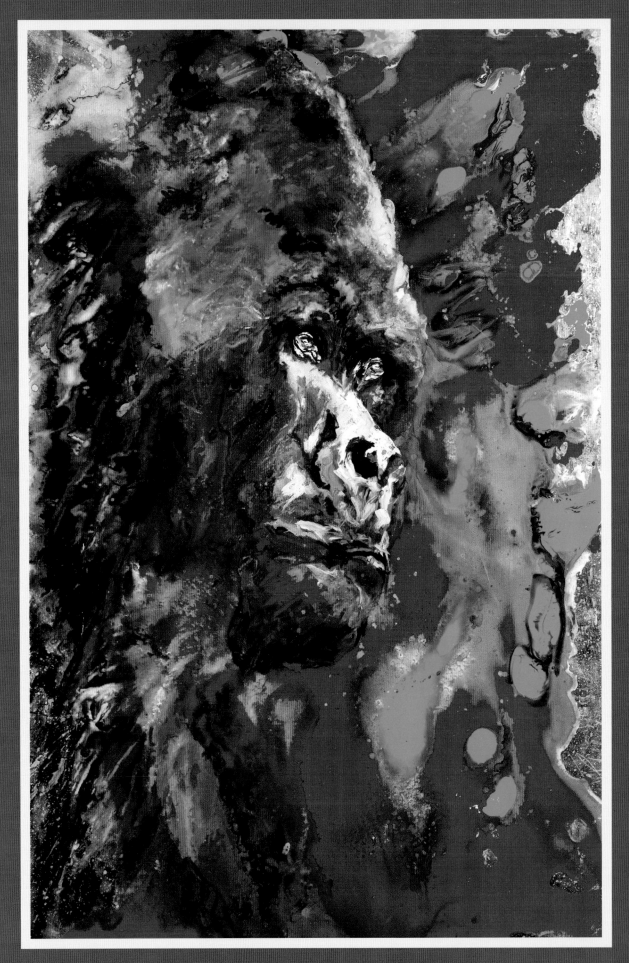

Oil on copper, "Cry"

of damp and the water droplets falling off the leaves remind us we are deep in the rain forest. The hand-carved walking sticks we purchased from the local villagers on the outskirts of the town of Ruhengeri prove very useful, helping us balance as we take each step, digging into the ground foliage and moist earth, damp from the light early morning rain.

More than four decades ago, American zoologist Dian Fossey fled a civil war filled with unspeakable atrocities on the Congo side of the Virungas, moving to the Rwanda side, where she spent the next 18 years sharing with the world her passion for the creatures that inhabit this rain forest. It is from here she wrote the memoirs that eventually resulted in her acclaimed book and the movie *Gorillas in the Mist.* In 1985 she was murdered by an assailant and is buried in the mountains she loved, at Karisoke, located in the saddle between Mount Karisimbi and Mount Visoke. Buried next to her is "Digit," her favorite silverback, and even today the villagers have been known to take the body of a silverback there to be buried alongside their biggest champion.

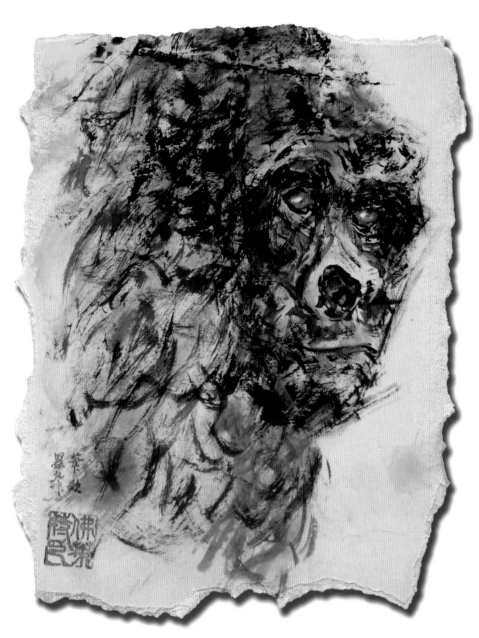

Sumi on rice paper, "Cry 2"

In 1925, this area was established and named Albert National Park, and it was renamed Virunga National Park in 1969. The park consists of eight volcanoes in a 50-mile (80 km) arc. We started our climb at 7,800 feet (2,377 m), with our objective this day to reach the Susa family group,

Dian Fossey's favorite, which in her time was comprised of 43 gorillas. It recently split into two groups, the Susa group and the Karisimba group. The current Susa group numbers 30, including a rare set of twins. The Karisimba group ranges higher on the slopes and includes 15 gorillas.

We want to return before dusk, because the forest is not a place you want to be at night. Our guide carries a machete, which he puts to use as we leave the prehistoric established trail and slice through thick vines and branches. Our walking sticks penetrate no less than six inches into the forest floor. The leader of the Susa has taken his group deep into the forest, but the trackers

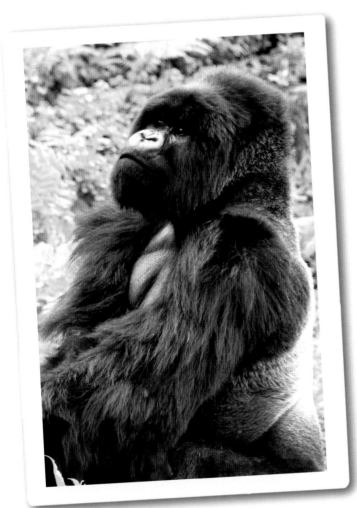

are not worried as long as we keep our pace. The group will forage two or three miles (3 to 5 km) a day and take mid-morning naps. The guides are confident we will catch up.

But to reach them as planned, we must stop only occasionally despite the steep, steady climb. This is high-altitude hiking, and it was a wise decision to hire a porter to carry water and a mixed bag of snacks. The survival of the mountain gorillas is threatened by poaching, but by my purchasing items like my walking stick and hiring a porter, the local villagers see less incentive to hunt these majestic primates. Alive, the gorillas bring in money every day.

The air is thick and humid, but a gentle breeze refreshes my energy and also brings an unfamiliar sound—click click, click click click. I soon discover it is bamboo swaying in the breeze and knocking together. We leave the bamboo forest and reach a point where we are able to look out toward the horizon; we are now above the clouds, and the early morning mist is still sitting in the valley below. The French describe this view of Rwanda as the "land of a thousand hills," and it is easy to see why.

Just ahead there is a massive hole in the thick underbrush, about 26 feet (8 m) in circumference, and the smell of fresh-cut celery is strong, together with a bitter odor I can't identify.

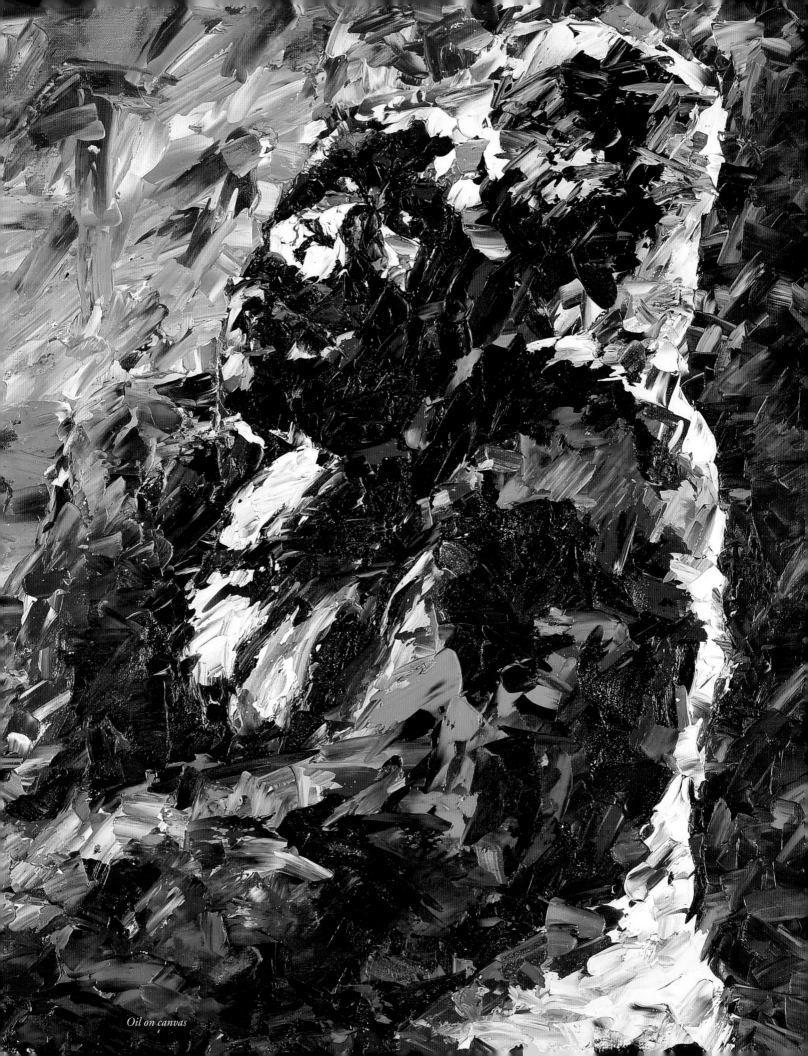

Oil on canvas

Our guide tells us this is the path of the Susa group, and we will follow their trail to observe them during their mid-morning brunch. We now have been climbing for over three hours. Our guide emits some gorilla-like grunts as we approach the group, so as not to alarm them. A young male crashes through the prickly vines directly in front of us. The gorilla family feeding and the youngsters playing—doing gymnast rolls and tugging at one another—has flattened a large rectangular area of the forest, about 30 by 65 feet (9 by 20 m). At the top of a slope, the twins hold onto each other as they tumble down to the foot of where the group's leader is seated, head held high and back erect—a powerful presence indeed.

Every year the village has a "naming party," and the newborn gorillas are christened after a characteristic or area. This impressive leader had been given the name "Cry" by the villagers, simply because, as an infant he apparently did nothing but that! We edge closer to Cry, but are interrupted by a female crossing our path with an infant clinging onto her back, as they will do until the age of three or so. As she passes, two males begin to slap one another and grunt in mock combat. Our guide tells us they

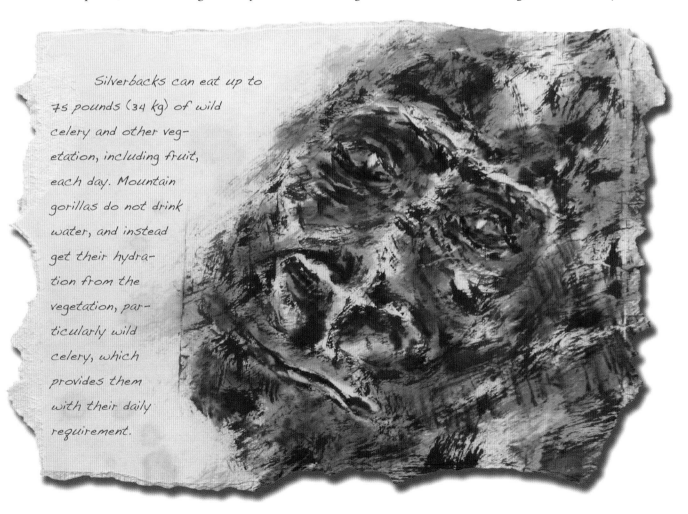

Silverbacks can eat up to 75 pounds (34 kg) of wild celery and other vegetation, including fruit, each day. Mountain gorillas do not drink water, and instead get their hydration from the vegetation, particularly wild celery, which provides them with their daily requirement.

are almost 12, at which age their backs will turn silver and they will be forced out of the group, or perhaps remain and wait for a chance to vie for the dominant male spot.

We approach the silverback and our guide pushes me down into a thicket of underbrush. Not nine feet (2.75 meters) away are a mother and her infants. It is a truly incredible feeling to be face to face with these spectacular gorillas. A ray of sunshine peeks through the dense canopy, shining on all three together just as one of the youngsters sticks out his tongue, a flesh color with a touch of flamingo pink. His eyes are vermilion and light cadmium yellow, wide with a sense of curiosity. His mother's eyes, an intense deep crimson filled with caution, are focused directly at me, watching my every move.

A bitter smell wafts up from the forest floor and off the thick fur of the gorillas, which are damp with moisture. I am intrigued to learn the gorilla's noses are all different shapes; in fact they are like fingerprints, and are how the guides tell one from another.

We have been here for an hour and now must leave, but as we begin our retreat, Cry knuckle-walks, intercepts our path, and abruptly sits, facing us. We are cornered between two trees with hanging vines and the thick underbrush and, directly behind us, the two younger male blackbacks. We remain still. Cry takes my breath away as he reaches out, his fingers the size of Coca-Cola bottles. He starts gathering stalks of wild celery; apparently we had been about to walk over a path of fresh celery that Cry had been saving for himself.

After pulling the stalks of wild celery and putting them under his thick, fur-covered opposite arm, he casually saunters back to his previous spot overlooking his family. It is clear who is the boss of this part of the forest. We begin our descent of the slope of Mount Karisimbi, arriving at dusk where we started our adventure nine hours earlier. It has been a day I will not soon forget.

Right: Hand-carved walking stick

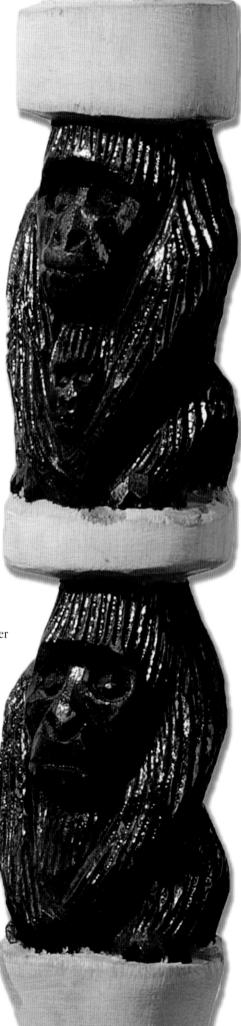

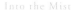

Into the Mist

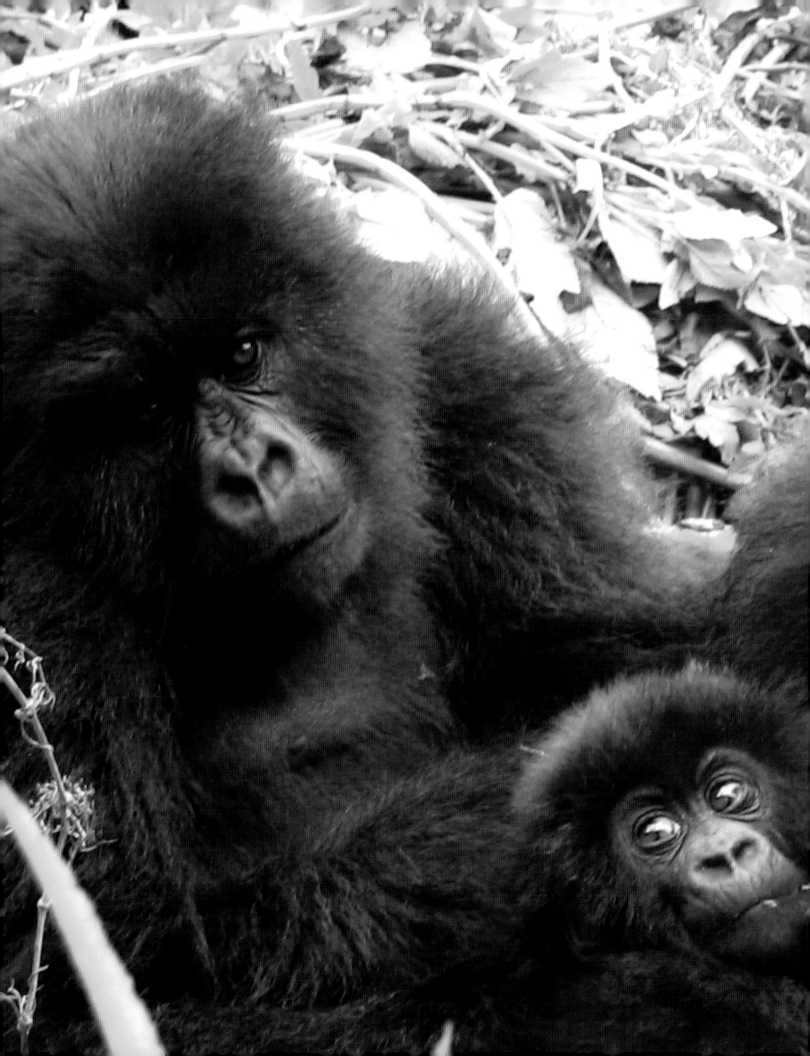

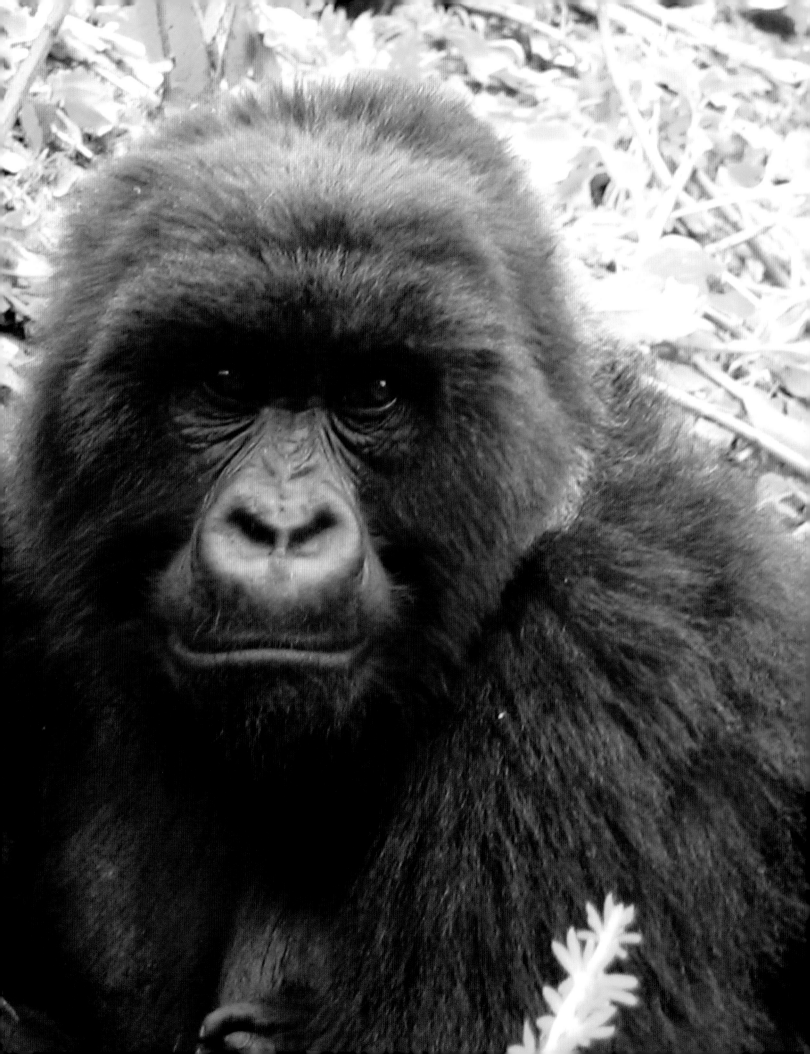

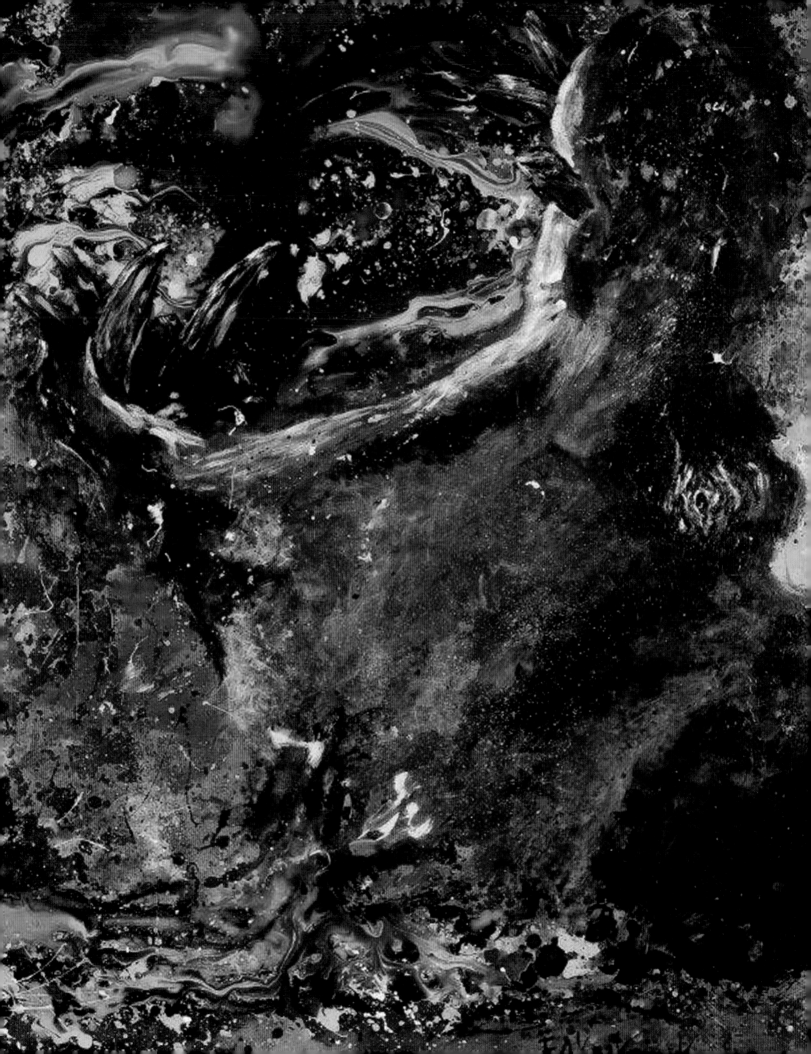

5

Lords of the River

It's dawn. We have just departed camp and are on our way down the calm and quiet Zambezi River, which is moving at its relatively steady pace of three to five miles (8 km) per hour. It's a glorious day to my artist's eye: the water is an ultramarine blue with a mix of viridian and the sun is just an absolutely radiant lemon yellow, throwing out beams of light as it is begins to peer above the acacia trees and climb into the eastern sky.

Left: Oil on copper

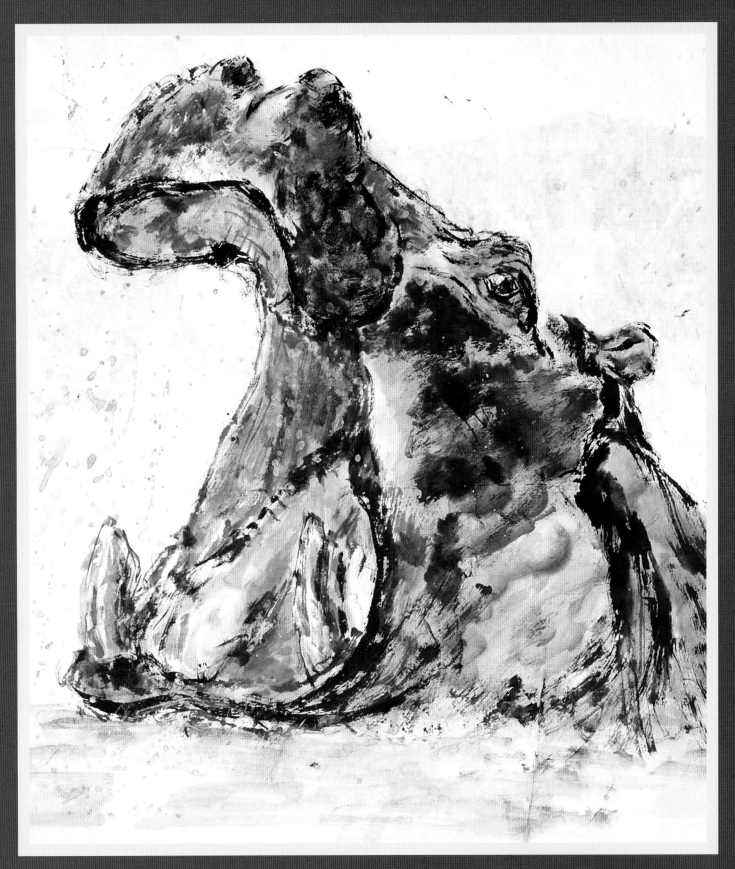

Sumi on rice paper

Birds are prolific in Africa, and they sing magnificently this morning, providing a perfect musical score to the peaceful scene. Impalas, zebras, and waterbuck casually meander to the river's edge for an early morning drink. As we glide down the river, I inhale the refreshing smell of the new grass growing along the banks. The only interruption to this blissful tranquility is the distinctive roar of a lion, followed by his guttural belch, which reverberates toward us from perhaps a mile or so upriver.

We float past a saddleback stork, a large black-and-white bird with a brilliant scarlet beak encircled with a thick black stripe and topped by the bright yellow "saddle" that gives him his name. His long, graceful neck stretches down to the water, where his beak breaks the surface. We have disturbed his morning fishing, however, and he extends his black-tipped wings, picks up his thin left leg, and accelerates his gait, peacefully taking flight without a sound.

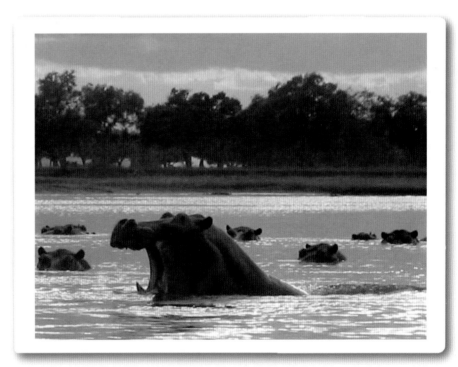

I pick up my binoculars and scan the horizon. Just ahead on the right shore I glimpse a massive, moving cloud of dust. Inside is a black mass—a stampede of Cape buffalo moving toward the water at a 45-degree angle. The dark shape is the catalyst—and a stunning contrast—to the yellow-ochre cloud of dust surrounding it. I motion and whisper to Humphrey to check out the stampede. But he stands up in his canoe, looks intently straight ahead, and puts his fingers to his lips to signal silence.

Maybe 40 yards (37 m) ahead, two hippo bulls are fighting in the shallows; the larger one is a blend of rose and viridian, resulting in an illuminated gray shine, the other a darker mix of ultramarine and burnt umber. Their huge shapes dramatically reflect into the cobalt-blue water as they surge their massive bodies upward and charge toward each other, mouths open wide in aggression, displaying their formidable ivory teeth, discolored to a deep Venetian red. Considering their mouths measure about four feet across and their lower canines nearly three feet in length, this is indeed a sight to see. Their earsplitting grunts echo over the water as we witness this clash of the river titans.

Unquestionably, we must avoid getting into the middle of this territorial battle, but as we turn due east from our northeastern direction in the channel, we find a barricade of hippos stretched across

Every professional guide is extremely wary of the hippo, and with good reason. Hippos are considered one of the most dangerous African animals because they commonly attack humans—whether on land or in boats—with no apparent provocation. Many people have reported boating mishaps with these giant beasts, which can weigh up to three tons. One Tanzanian guide told me a story over a campfire about two massive bulls fighting violently. Suddenly the losing hippo turned abruptly and went searching for revenge, taking out his wrath by upsetting a dugout canoe piloted by a local tribesman downriver. Explorers dating back to Stanley and Livingston all had tales of hair-raising encounters with these enormous and extremely aggressive beasts. The unpredictable hippos are undoubtedly kings of the river, dominating the water with their huge canine teeth and sharp incisors.

I have come across manuscripts that tell of Zulu warriors who preferred to be compared to the hippo than the lion, because they considered the hippo much fiercer.

the entire arm of the river, a veritable minefield from one shore to the other. We slowly glide single file in our canoes, maneuvering across the channel from the south to the north at about a 60-degree angle. We must be very cautious.

For reasons I don't completely understand, I decide to place my paddle across my lap and carefully turn to my right to capture a photo of this incredible barricade of hippos, an awesome sight. I raise my camera, and at the very same instant, a giant bull with his jaws wide open emerges from the water right in front of me. Knowing this is a signal that the hippo feels threatened, I immediately drop the camera. (I am still thankful that the neck strap was on.) Almost simultaneously, Humphrey shouts, "Paddle, Fred—paddle now!" as a hippo to my right submerges. I know why Humphrey is shouting. The wake created by the submerging hippo is arrow-shaped, and the point of the arrow is heading directly toward my canoe. I dig into the surface of the water using my torso muscles, and make quick, small "J" strokes to move forward, fast and straight. "Move it!" Humphrey shouts again.

Incredibly, the hippo just skims the bottom of my canoe and the wake barely passes behind the stern—way too close for comfort. Hippos are still submerged from shoreline to shoreline, their bodies designed in such a way that only their beady Prussian-blue eyes, Indian-red ears, and nostrils peek out above the waterline. Their small, cupped ears twitch, and every now and then one opens its enormous mouth, scoops up water, and makes the unmistakable hippo grumbling and grunting sounds that can be heard for miles. With no small amount of relief, I reach the bank behind Humphrey's canoe and grab for a root that extends from the shore. We rest for a minute to reassess and figure out how we will cross the path of these hippos.

Humphrey has us stop along the raised bank. We hold onto the overhanging grass, roots, and fallen branches that line the shore while he peruses the landscape. The stampeding Cape buffalo are ahead on the north bank, and these hippos are certainly giving no quarter. The two quarrelling bulls on the opposite bank have broken off their fight with no apparent winner, but the gashes on both show they are old warriors and this won't be the end of their dispute. Humphrey, who is all about being secure, decides we should wait until there is a safe opportunity to go around the hippo barricade and ma-neuver past the menacing Cape buffalo. He does not want to cross the channel to the south shore where the two aggressive bulls are meandering. So we sit silently, watching the hippos move about, staring at us curiously, occasionally opening their jaws wide to show their giant, sharp incisors. It is clear that hippos do not fear humans.

It's time. Humphrey whispers that we will continue slowly, hugging the shoreline. I choose to use the grass and branches

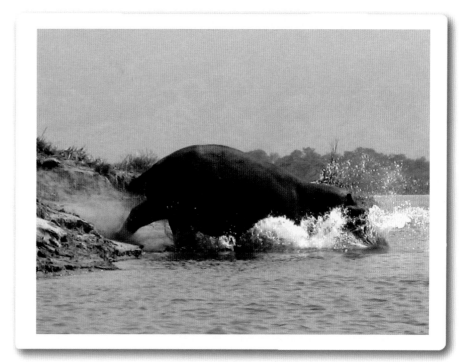

overhanging the bank to pull my canoe along, only occasionally using my paddle. It seems to take an eternity under the ever-watchful eyes of the hippos, but we finally pass the remaining few in the back of the pod.

Still up ahead are the Cape buffalo, now foraging in the shallows of the river. This is another African animal to be respected. Many people don't realize the Cape buffalo is one of the

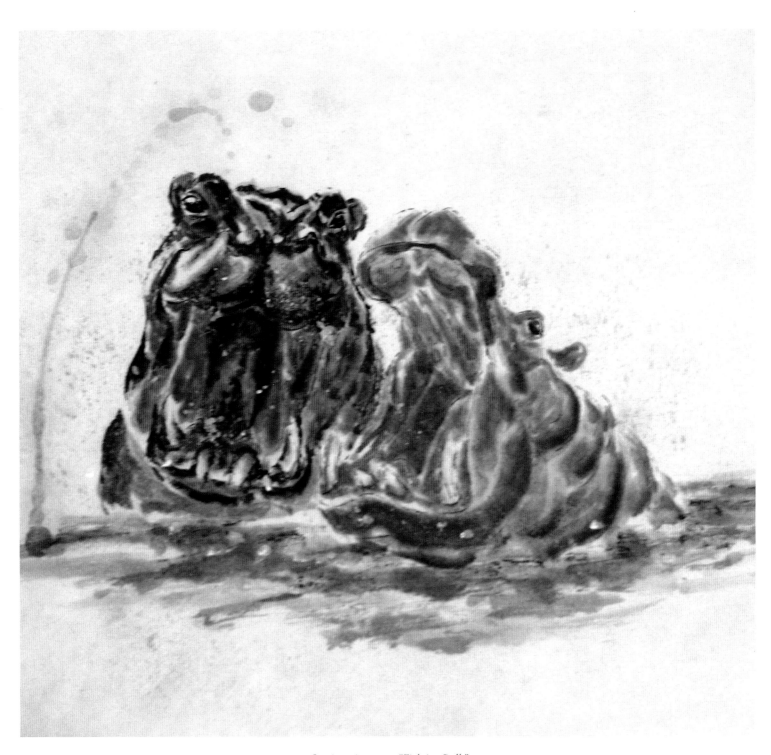

Sumi on rice paper, "Fighting Bulls"

Africa's "Big 5," prized by hunters because of their viciousness. Although they can look deceptively docile and cow-like as they graze on the plains, the buffalo are considerably dangerous, goring and killing more than 200 people every year. If wounded by a hunter, they are known to circle back and stalk their attacker, waiting for an opportunity to charge and maim with their dangerously sharp horns.

Although we are certainly not hunting, we still must give this herd a wide berth, and Humphrey instructs us to follow him, taking a 45-degree angle back across the river to the southern bank of this channel. It appears most of the herd are grazing, knee-deep in the water. Several lift their heads and stare at us with a menacing glance that pierces straight through. Droplets of water fall from their steely gray muzzles, and viridian and sap-green blades of grass stick out from their mouths as they chew. The early morning rays of the rising sun bounce off their mud-stained horns, which remind me of a gridiron helmet.

As we pass these formidable beasts along the southern shoreline, I note that with the sun now higher, their reflection in the shallow pool of water shimmers in an artist's palette of colors—dark, bluish phthalo green; warm burnt sienna; brilliant emerald green; a blackish-blue Payne's gray. I leave my camera around my neck and focus on getting past these morning grazers, making sure, however, to embed this picture in my memory for a future painting.

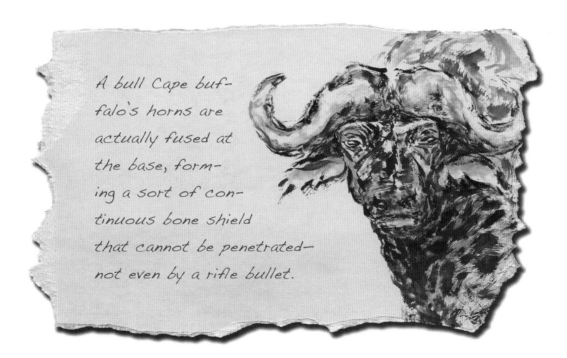

A bull Cape buffalo's horns are actually fused at the base, forming a sort of continuous bone shield that cannot be penetrated—not even by a rifle bullet.

In the Eyes of the Guide: The Rookie

BY HUMPHREY GUMPO

My first assignment into the "real" wild and remote Africa was with five trainee colleagues in March 1998. Here is my recollection of that time.

I am as green as trainees come, armed with a map drawn on the back of a cigarette box; a seven-ton truck full of thatch grass, camp maintenance equipment, and supplies; and a Land Rover for game drives. We venture off in search of Chikwenya Camp on the eastern border of Mana

Left: Watercolor

Pools National Park. The drive, we have been told, will take seven hours, with a few river crossings and tsetse flies encountered along the way. We have been particularly warned about the area close to the camp, where apparently there is thick jesse bush teeming with grumpy old Cape buffalo bulls past their prime. We've been advised not to stop to relieve ourselves after we have gone past a certain giant baobab tree.

As expected, we encounter not a few, but hundreds of tsetse flies, and spot the occasional antelope through the thick emerald vegetation of the rainy season. Amazingly, many wildlife areas in Africa owe their continued existence to tsetse flies, the Okavango Delta in Botswana being one of them. While most wildlife had developed a tolerance to the "sleeping sickness" carried by the tsetse fly, cattle did not, and areas once thought of as prime grazing land for ranchers in the early 1900s were left alone because the tsetse fly could not be eradicated.

Our first hurdle comes when we cross the "little" Zumbu River, and spend two hours trying to get ourselves unstuck. The fear of the unknown takes over. This was supposed to be the easier of the river crossings! We finally extricate ourselves, and as we arrive at our next challenge, the Sapi River, we face a swollen mass of rushing water, transporting logs and debris along its chocolate-brown body. We wait two hours for the river to recede, and finally decide it is shallow enough for the truck to cross. We draw straws to see which of us has the dubious honor of driving it, and in goes the truck, revving its way through the shallow crossing. But alas, it manages to find a hole midway, coming to a halt and sinking not only itself, but also a few hearts. Efforts to get it unstuck are fruitless, and we decide to cross in the smaller vehicle, make our way to camp, and return later with help. This, however, is wishful thinking, because the Land Rover, despite its admirable ability to cross rivers, isn't going anywhere in a hurry.

The two vehicles now stand side by side in the rising river, with the orange hues of a summer sunset creating a magnificent backdrop to a dire situation. As it gets dark, we all pile onto the vehicles for safety, wondering when the river will stop rising. The night is long, and the sound of the river now flowing through the Land Rover dampens any hopes we have of trying to rescue at least one of the vehicles.

Dawn arrives, and it is brutally evident that we have to make a plan, so we draw straws again. I volunteer to wade across the shallow river with three others and walk to the camp. We arm ourselves with one machete and "slashers." Taking a map with us, we set off. Herd after herd of elephants bring us to temporary halts on our journey, and eventually, after midday, we catch a glimpse of the giant baobab marking the beginning of the "danger zone" of which we had been warned. Although this is in some ways a welcome sight, it feels like walking into the set of a horror movie. Dreading encounters with the

great horned beasts known as Cape buffalo, we decide it is wiser to swim down the murky river than walk through the thick, jungle-like forest.

We hope the water is too murky and roiling for any self-respecting crocodile. We make a pact to stay together and vow that if anyone feels so much as a nibble, we will all help each other. After a two-mile swim in the shallow Sapi River, we begin to see the blue waters of the mighty Zambezi, and at that instant we all have the same thought: get out of the water, because we are about to enter the territory of the 16-foot (5 m) "flat dogs" (Nile crocodiles). We leap out of the water, and as we get back on land, we cannot believe our eyes. The rustic Chikwenya Camp is there before us, and the off-season camp staff are shocked to see us emerge, soaking wet, from the Sapi River.

The cold cola I guzzle next is easily the best I have ever tasted, as is some hot bread fresh out of the bush ground oven. The enjoyment is short-lived, however, as we now have to figure out how to rescue the truck and save our jobs. Fortunately, by the time we get back to our stuck truck, an hour's drive away, the river has receded, allowing us to drive straight out. Later we will calculate we had walked about 15 miles (24 km) in seven hours.

This was quite an introduction to remote Africa, but experiences like this have imprinted the adventurous bush character in not only me, but pretty much all who have visited this wild and beautiful land I call home.

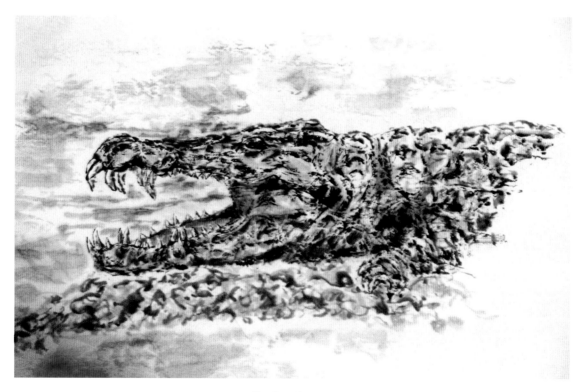

Sumi on rice paper

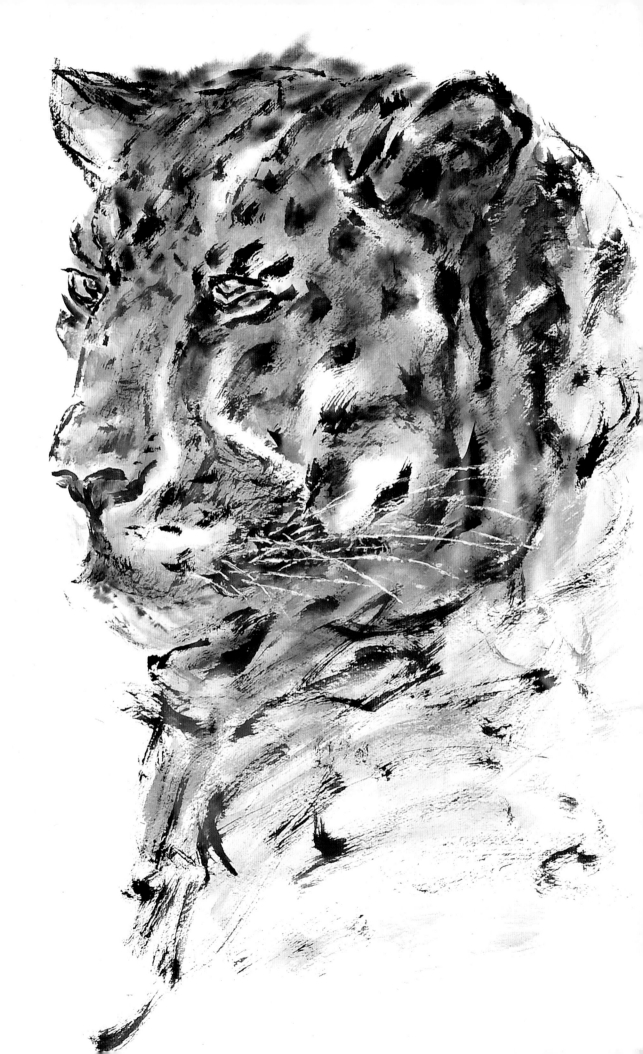

7

In the Eyes of the Guide: CSI Africa

BY HUMPHREY GUMPO

I set out on an afternoon game drive with a French family: the father, an avid photographer; his nature-loving wife; and their two daughters. About 45 minutes before sunset, we see clouds of dust, vibrant and slightly eerie against the orange light of the setting sun. In the dry months there is only one animal that can kick up this much dust, and there are only two instances in which it happens: when chased by predators or when running to water after traveling long distances.

Left: Sumi on rice paper

Sure enough, we encounter a herd of about 300 Cape buffalo heading for an afternoon drink in a hidden section of Long Pool—one place that everyone who visits and experiences has difficulty leaving. Long Pool is the first water that animals will reach on their journey to the river from the dry interior of Zimbabwe's beautiful Mana Pools National Park. The pool is an ancient oxbow of the Zambezi River,

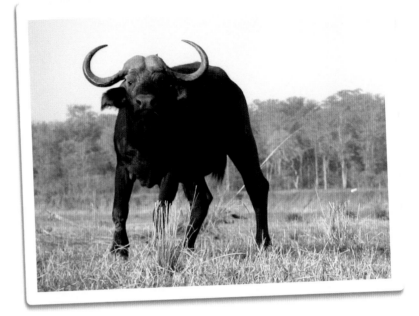

and the alluvial silt enables it to hold water year round. In the dry months, large concentrations of hippos live here to reduce their commute between the river and inland grazing pastures. This "pole position" comes at a price, though, because when the water dwindles, territorial battles are ongoing and often fierce. This, together with a large concentration of crocodiles basking along the banks—gaining energy to overpower and drown any potential prey—is what makes Long Pool so renowned.

Today is different, however, as there are more than the usual cast of characters in this theater of the wild. Positioning ourselves on the opposite side to where the buffalo are drinking, we enjoy the challenge of photographing silhouettes as the thirsty bovids push and shove for better drinking positions. Different bellows echo across the water to where we photograph, lying down in an attempt to avoid our human profile creating interest from the feisty matriarchs leading the herd.

Suddenly, the mood changes, and the bellows of the herd are replaced by that of one yearling calf. All the buffalo leave the water's edge momentarily before returning to investigate the option of a rescue mission. The young calf is in the deadly jaws of a 10-foot (3 m) crocodile. Disbelief lingers in the air for us, the buffalo, and the crocodile—a disbelief that is to be with us for the next 18 hours. The typical splash, grab, and drown technique of the lethal predator is not possible, because the water is not deep enough. The crocodile still holds on in hopes of eventually dragging the calf into deeper waters, but it is evident the young buffalo is not about to give up easily. It digs its hooves into the ground as if it is a raging bull. Its mother comes to attempt a rescue, but to no avail. She stays close to her calf for some time, but after a while leaves to join the rest of the herd, which had long walked away with remorse. The calf is not lost yet, but they know their journey has to continue. Another crocodile tries to bite the young buffalo from the front, but a lesson is learned when the buffalo violently tosses its

head, hitting the smaller crocodile with great impact. The wise reptile does not wait to be told twice, and immediately flees the scene.

After another 45 minutes, the sun has set, but the young buffalo calf remains in a tug-of-war, sometimes losing and sometimes gaining ground in the shallows of Long Pool. The strength in the crocodile's tail is visible from a distance. In preparation for their night of foraging, hippos start grunting and leaving the water, which is when we decide to return to the safety of our vehicle. However, we are not about to leave the scene. Now we park much closer to the action, and just as we get into position, two hippo bulls make their way toward the crocodile and the buffalo. We're all thinking the same thing: it looks like the hippos are coming to finish off the buffalo. It took years—and, finally, video footage—to convince me this is even possible. Today is different, though.

My guests ask me what is about to happen. Until this very moment, I had thought myself capable of answering any questions on safari, albeit sometimes with a slight diversion from the question followed by a conclusion of further research. This time I am caught out. I do not know what is about to happen, and I don't hesitate to tell this to my guests. In an instant, they understand and simply watch.

One of the hippo bulls moves in, jaws wide open, and prises the crocodile off the young calf. Another hippo threatens the crocodile by shaking its massive head and showing its large canines, which glimmer in the moonlight. I certainly appreciate having good binoculars with me, because we are all able to follow this amazing action in the descending darkness.

The buffalo now free, the hippo bull nudges the tired and shocked calf some 30 feet (9 m) back to the riverbank—and to a spot right in front of our vehicle. After the calf is safe, the hippos carry on with their

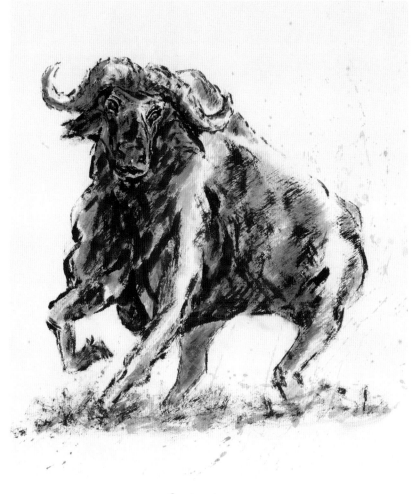

Sumi on rice paper

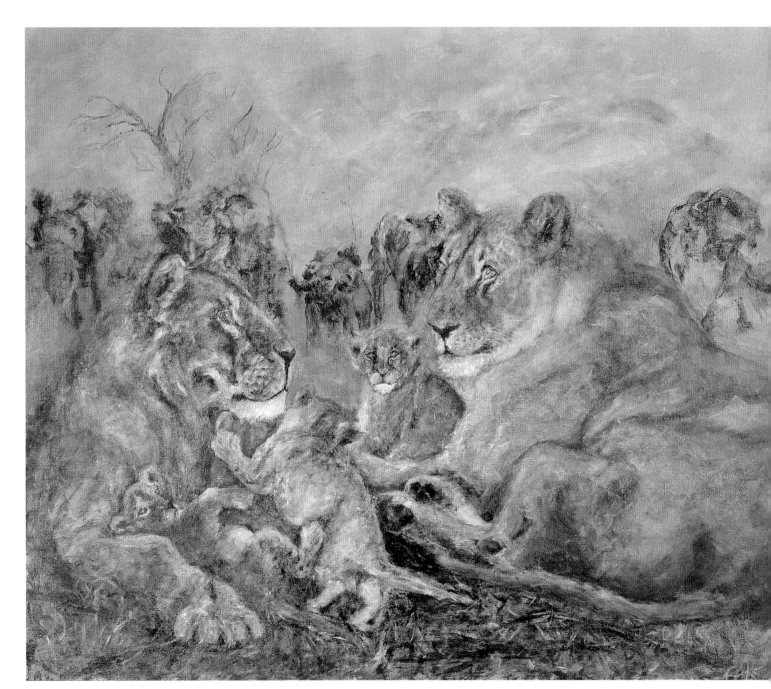

Acrylic on canvas, "Pride of Lions"

routine. The calf's hindquarter is probably very stiff, but it is determined to join the rest of the herd, who must now be more than a mile away. He bellows to get the herd's attention.

But that mournful bellowing has been heard by something else. In semidarkness, we make out a shape walking past. Hunchbacked and without the typical cat stalk, it suggests—and the vehicle lights confirm—the presence of a brown hyena. The hyena goes straight for the mouth of the calf, but gets the fright of his life when this tired but brave calf tosses him more than three feet into the air. It is clear this calf is a real fighter, and his determination is still alive. The big hyena, though, is cunning and probably very experienced, because it launches an attack from the rear. Words cannot adequately capture the explosive combination of sounds that ensues. There are more hyenas whooping and giggling in the distance, in a fashion designed to call the masses, alert them of this possible meal, and create frenzy. By now we have become attached to this young survivor, but, in a majority vote, we reluctantly decide it is time to leave. We all agree to be back before dawn to try and determine the rest of the evening's story.

We get an early start the next morning from our mobile tented camp and are on site at first light. What follows would keep the world's best wildlife CSI teams busy for hours. As a guide, the time I feel most passionate about my responsibility of translating events on safari is when I have to patch together happenings and timelines from a confusion of tracks, bones, and sometimes distant sounds. We walk around the area for more than half an hour, looking at drag marks, claw marks, and tracks on the ground and in the mud, and, most importantly, the distance between where we left the calf and where his stomach contents now lie.

From what I can determine, after we left, the scene turned into a frenzy, because from the tracks it looks as though between eight and a dozen hyenas were present. A male leopard even walked the area, most likely while only one or a few hyenas remained, because vying for the carcass on the ground against a pack of frenzied hyenas could prove fatal for even the largest leopard. Then the party was apparently interrupted by a big male lion, in the company of two or three lionesses. These big cats would have confronted the hyenas and eaten what they could. The hyenas would have gathered their crowd enough and moved in after the lions had their fill, repossessing the carcass and whatever was left and dragging it away.

Now, all that is left in an area of about 200 square yards (167 square meters) are two keratin hoof ends and a few bones. There is no sign at all of the buffalo's main body parts (head, spine, and leg bones). Had we not been there the night before, events leading up to this scene would be a real challenge to understand, let alone translate, from the riddle of tracks in the earth. Our jaws hang in astonishment when we realize that a leopard, many hyenas, a small pride of big lions, and who knows what else had visited this "crime scene" after our departure.

As somewhat of a consolation for missing part of the action the night before, we leave our vehicle and set off, following the lion tracks. We are now the predators, determined and vengeful, and defeat is looming. We lose the tracks many times on hard soil and across grassy patches, but somehow we always find at least one

again. Our goal is very clear: find the two lionesses and one male who left fairly clear tracks on the sandy patches of Africa last night.

Three hours into the walk, we stop for a drink and a little snack as I try to compose myself. The possibility of not finding these cats is getting more likely as the sun rises higher in the sky. Tracking is best done in low-light angles, preferably with sun behind, as this casts a tiny shadow on the track, which is vital to staying on the pattern. This shadow is no longer visible as the sun rises in the sky, but there is no giving up.

Vegetation changes from the dominant mopane woodland to jesse (the Afrikaans word for thick) bush to areas of savannah grassland, and back to mopane. The thrill is evident among the whole party as we all work on the tracks, bringing to mind the expression that "the hunt is better than the kill." But in order to compare, we want to see the "kill." In our case, though, the hunt is the tracking and the "kill" is spotting the predators we pursued.

Unknown to us, it literally is a kill. The first sound that catches our ears is that of animals fighting, growling back and forth at each other. We creep in very slowly, using the cover of some indigofera bushes, until we can make out tawny shapes moving back and forth against each other and hear the sounds so clearly they could have been in our midst. The noise and the fact that the lions aren't really aware of their surroundings help us to get within about 65 feet (20 m) of this raucous melée, at which stage we catch the occasional glimpse of thick bands of black and white stripes. They are feeding on a fully grown zebra. Disbelief again! Even though we can see all this clearly with the naked eye, looking through binoculars gives us almost a 3D cinematic effect.

The pride is comprised of one male, four lionesses, two cubs of about 18 months of age, and three small cubs we estimate to be four or five months old. Judging from the amount of meat already off the carcass, it is apparent the kill is more than 24 hours old. Most of the softer meat had been eaten, and the stomach contents lie about 30 feet (9 m) from where the carcass was, already dry from the previous day's sun. This turn of events then makes us realize something that again I had never known was possible—the pride had been feeding on the zebra when they heard the commotion at Long Pool (about a mile and a half away); the trio left to investigate, took over the carcass from the hyena, fed a little, maybe lay around a while, and then returned to the zebra carcass. It is unbelievable.

About half an hour into our encounter with the big cats, the wind picks up and changes direction, a typical phenomenon in the Zambezi Valley just after mid-morning. We call it the "Mozambique fan," in which the breeze turns into strong wind in August and September and blows from the east along the valley floor as temperatures warm up. Our scent comes as a surprise to the pride, part of which scurry for cover. The male and the lead lioness do not move an inch, however, showing their dominance and confidence, and, to any viewers in their right mind, confirming they will stay with that

carcass come high wind or crazy guide. The older cubs come back now, looking at us and wondering where we came from, but the other lionesses lie down under the bushes. It is time to wind down for the warm part of the day before serious feeding resumes in the late afternoon.

After a while, even in our presence, they all relax enough that we can hear the sound of the three younger cubs, letting off little growls and moans as they suckle, followed by the mother's growl whenever one of the cubs bites too hard. We shift positions a couple of times to get our "friends" to relax and realize we mean no harm (and to get in different photographic positions), but all the time we are there, the lions' eyes are on us. Eventually, it is time to leave. The walk back to the car is never as exciting as the time away from the vehicle, but the constant replay of the events of the last 18 hours keeps us occupied during our journey back. Not surprisingly, even though we are on a 28-day safari, seven days of which we spent in Mana Pools, the guests want to stay even longer. This part of Africa seems to have that effect on everyone who visits, and it is easy to understand why.

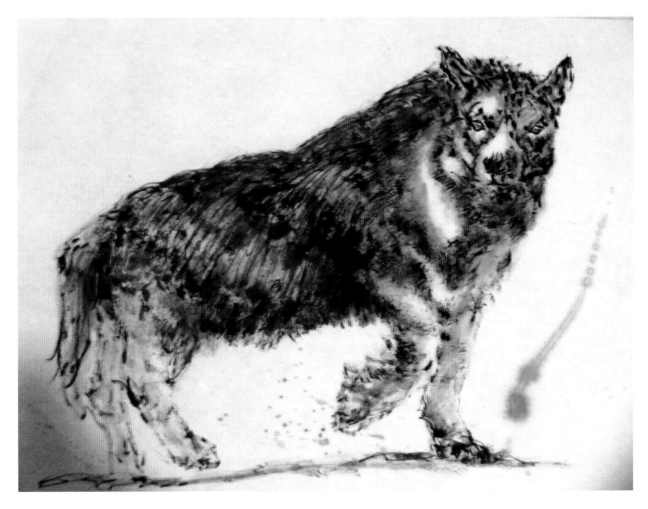

Sumi on rice paper, "Brown Hyena"

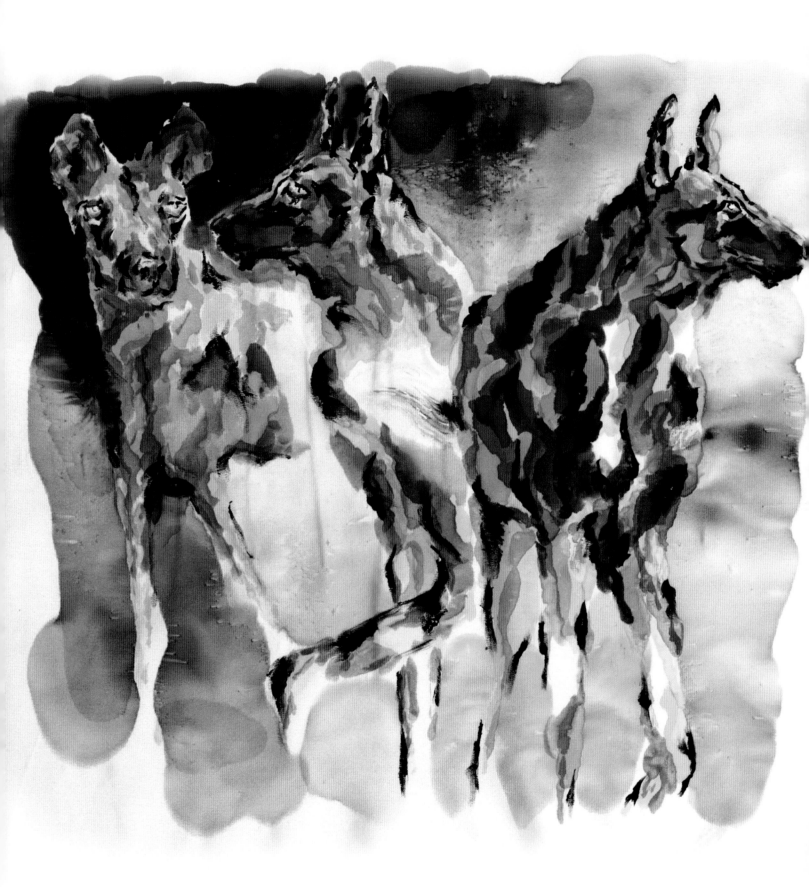

8

Into the
Wild

It is dusk and the sun is setting. After a full day of tracking, we walk back to camp in the shadows of the acacia trees, but our return is interrupted by a kudu, which sprints 20 feet (6 m) or so in front of us. Its eyes are wide open as it darts by, the pupils dilated in response to the extreme emotion it now encounters: fear. Our eyes follow the elegant creature as it runs toward the channel only 50 yards (46 m) away, the thick

Left: Dye on silk

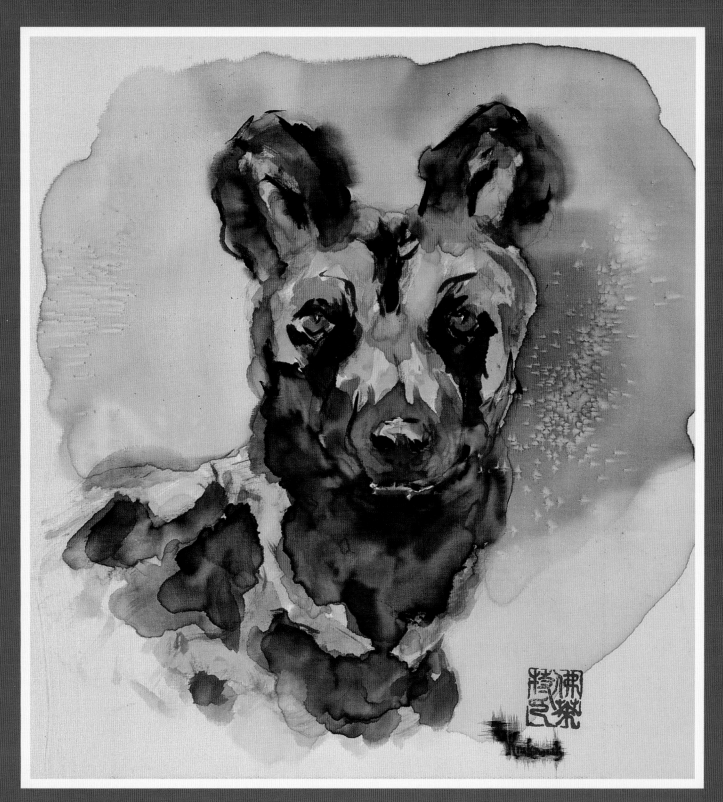

Dye on silk

underbrush from whence it came now to our backs. Faintly we hear a synchronized panting, followed by the rhythmic beat of paws striking the ground—wild dogs, in concentrated pursuit of the kudu, legs stretching out and chewing up the terrain.

Cleverly, the dogs have arranged themselves into an arrow-shaped formation, covering almost 30 yards (27 m) across. Their white tails point straight out from their body and they hold their heads forward and high. Their intently focused eyes are a bright cadmium orange and their muzzles a dark luminous gray highlighted with cobalt blue and violet, reflecting a touch of the sky, colored scarlet by the setting sun. The dogs' coats are a patchwork of hues: deep blue and burnt umber with touches of brilliant blues and golden yellow, burnt sienna and deep crimson. We find ourselves in the very middle of their formation, and as they pass us we begin to sprint with them, ignoring the weight of our packs.

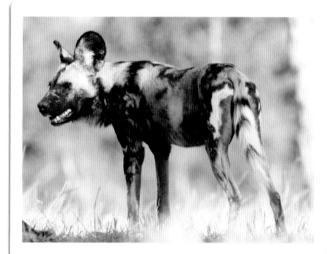

The wild dogs smoothly traverse the terrain, while we mere humans duck under branches and jump over fallen trees in an effort not to trip and fall—or, worse yet, hit our heads on a low-hanging limb. The wild dogs, intent on their mission and not bothered by our presence, pull away from us, but we continue to follow them. We watch as the kudu jumps into the safety of the narrow channel in a narrow escape from sure death.

The entire pack now lies down and rests in an open area, panting heavily, their heads silhouetted against the horizon of a deep cobalt-blue and scarlet-red sky as the sun sets over Zambia. We are in very close range, and easily catch their scent, which, simply stated, is atrocious.

It is now approaching dark, and as the dogs' silhouettes fade, they rise and vanish into the deep blue night.

As always on safari, we are constantly on the lookout for wild dog sightings or their spoor. If one considers how much wild dogs weigh (40 to 75 pounds [18 to 34 kg] on average), it seems they float across the terrain, for they very seldom leave a trace except when traveling over loose gravel. Nevertheless, Humphrey, always alert, one day points to a fresh wild dog spoor and instinctively looks out across the savannah, where a pair of ears appear from behind a fallen acacia tree.

We continue on for about a 100 yards (91 m), parallel to the dogs so as not to alarm the pack. There appear to be about 15 of them, with six lying under the shade of a tree and the others spread about, wrestling playfully or resting in the midday sun. Our objective is to be accepted by them and join in the festivities of the pack. This will take time and caution.

Overseeing the entire scene is a lone Cape vulture, lurking in the hollow limb of a dead tree, gazing out over the horizon, no doubt hoping he can take advantage of any scraps the dogs might leave behind after a

The stench of the wild dogs is no doubt a result of their habitat and hunting habits; they literally tear at the underbelly of their prey. (As gruesome as it sounds, this is much more humane than the method of lions, who suffocate their prey, a drawn-out and more excruciating death.) The hunters then regurgitate their kill when they arrive back at the den to feed the rest of the pack; the pups are often covered in blood. This practice naturally attracts ticks and other insects, and certainly must have a direct effect on the odor of their coats.

kill. After perusing the landscape, Humphrey suggests we traverse the distance between us and the woods, staying quiet and as low to the ground as possible; we do not want to alarm the vulture, who would consequently alert the wild dogs and send them scattering to find another play area.

Crouched low to the ground, we begin our trek. We crawl on our hands and knees, thorns piercing our clothing into our legs and hands, which are already scarred from the rough African terrain. We continue to crawl over fallen trees, scooting on our backsides down and through ravines. After an exhaustive crawl, we arrive only 20 yards (18 meters) from the pack. Even on the fringes, the smell is overpowering, making me squint. I extract several pebbles that are lodged into my hand.

The fallen acacia tree in front of us is our last hurdle, and then we will be in the midst of the pack. We hope the dogs will not be startled by our presence. The vulture is still perched overhead, his beady eyes glaring at us malevolently.

This is now a game of chess. We cautiously maneuver over the tree and sit quietly. Not wanting the wild dogs to sense my anxiety, I take deep, slow breaths. A couple of the dogs move toward us, walking cautiously, staring at us with their black opal pupils, obviously curious and fearless. They appear to accept us as they come within arm's reach, and I notice in even more glory their colorful coats in the afternoon sun, a brilliant, majestic tapestry of hues. Their black muzzles are square in my face; they are as suspicious as I am, but without my nervous energy.

After the initial two "point men" inspect us, the pack continues on with their afternoon, apparently unfazed by their uninvited guests. Every now and then another one or two wild dogs swing by to check us out, some with a curious stare and others with a more intimidating one.

The next four or more hours are pure entertainment. We are mesmerized by these beautifully colored dogs. Like children on a playground, some play tag or hide-and-seek, while others relax. Then the dogs all suddenly begin to stretch, reaching their front paws out and pushing their rear ends toward the sky, their white-tipped tails seeming to touch the clouds. The sun is setting and the time is ripe for some action. Humphrey puts his index finger to his lips and then touches his eyes with two fingers pointing outward, instructing us to be quiet and watch closely.

In unison these colorful canines begin a rough ritual of darting toward one another, leaping over each other, rolling on the ground in hyena dung, chest butting, nipping, and biting. Eventually they form a semicircle around our position and start running furiously, creating a dust devil of sorts. "They are prepping themselves for their evening hunt," whispers Humphrey. "Very few humans ever have the chance to experience this."

The moment is almost indescribable; being in the midst of the exhilarating nervous energy of the wild dogs is unparalleled to anything else I've experienced in my African travels. There is so much activity and I am so caught up in the energy that sadly I take few pictures of these dogs, who are now infused with a crazed, kamikaze spirit and about to go their way on a hunting venture. As we watch them dash off into the sunset, none look back and we are forgotten—but my memories of this afternoon will unquestionably last forever.

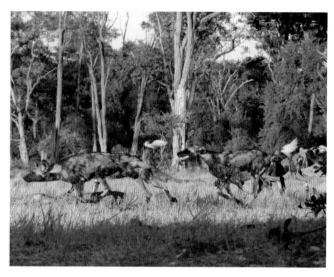

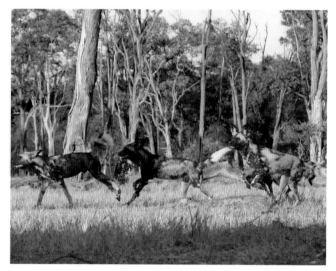

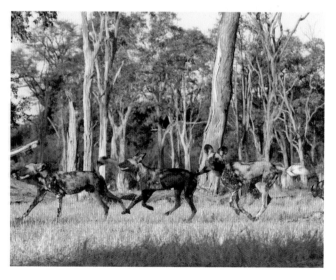

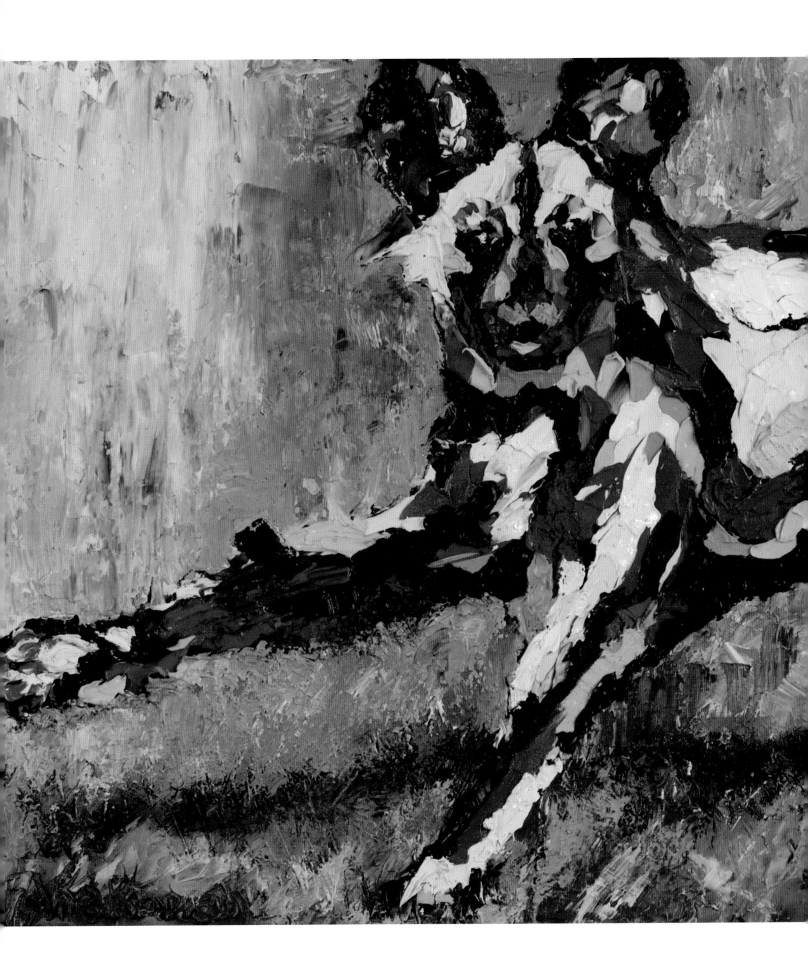

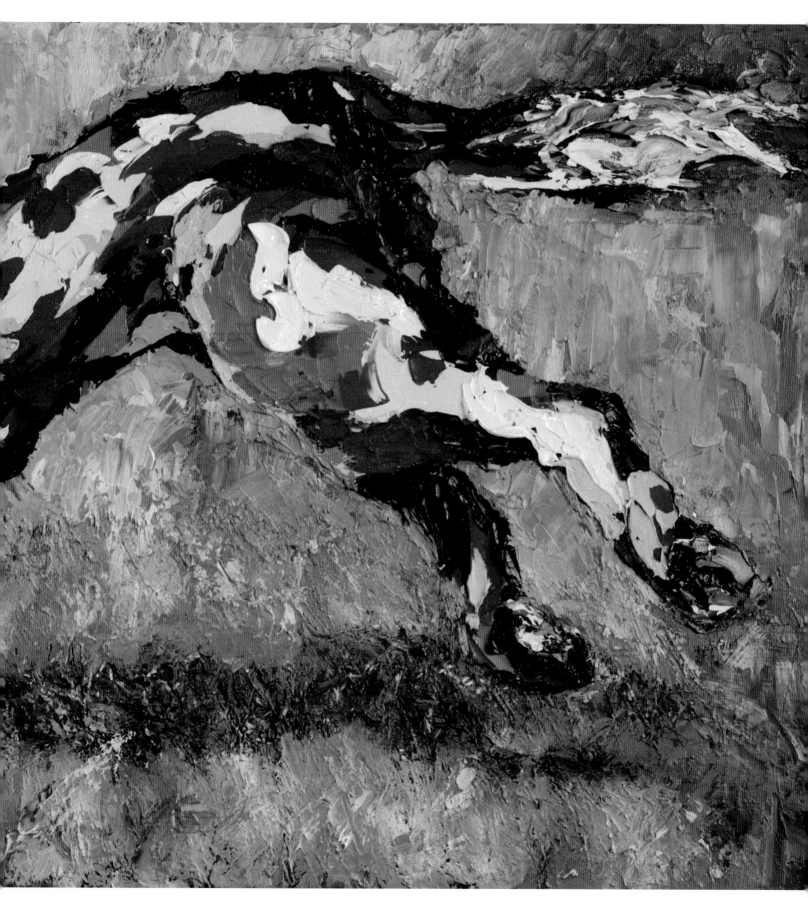

Oil on canvas

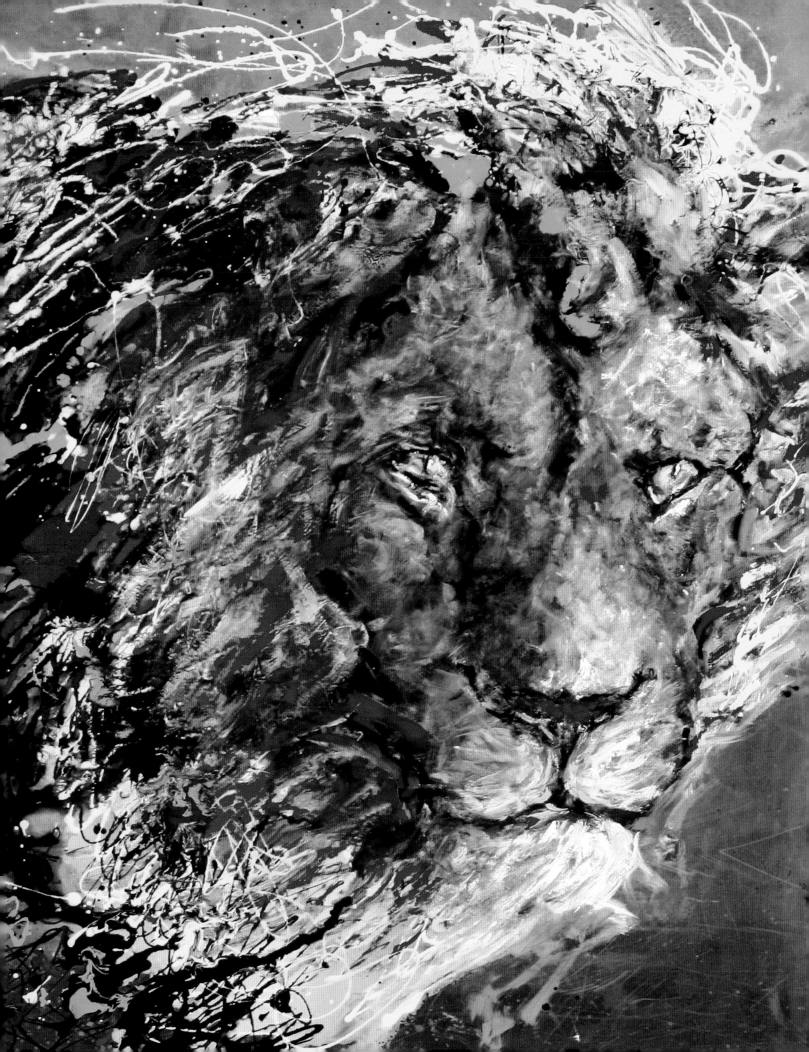

CHAPTER

9

Outwitting the Kings of Beasts

It's another tranquil day on the Zambezi River. Humphrey instructs us to pull our canoes off onto the sandbank of Nyamatusi Point to stretch our legs. Almost immediately he spots a lion spoor, and then another. He smiles, knowing we are always looking for adventure, and says, "Let's track these two male lions a bit."

Left: Oil on copper

85

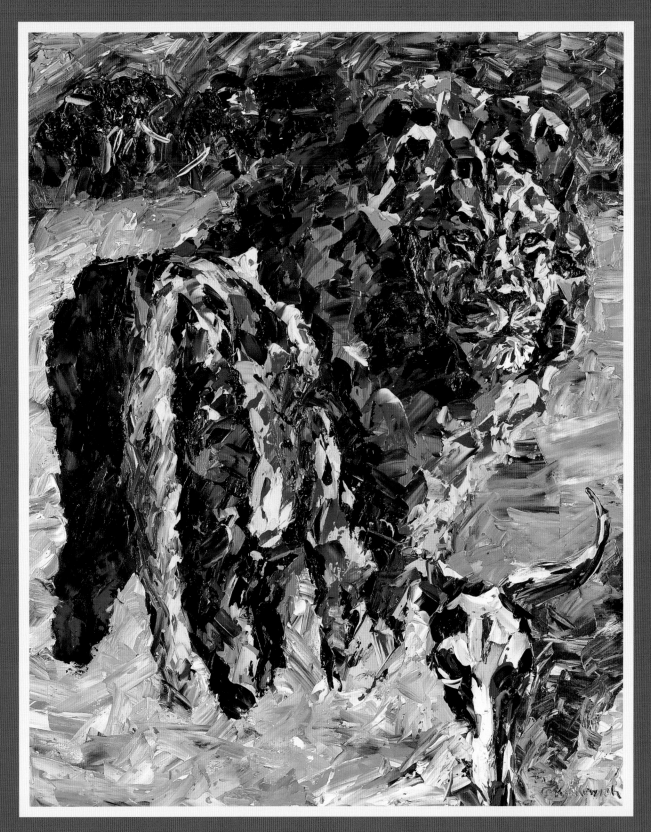

Oil on canvas

Humphrey has taught me that you always read tracks forward and backward to get the big picture, never isolating on one track or direction. The tracks here point to the west, and there are a vast number of animals being very vocal in that direction—from elephants and hyenas to birds, baboons, and eland.

Humphrey surveys the landscape and inspects the pugmarks, including the depth and width of the tracks, looking for a weight shift or perhaps even the traveling speed. Then, obviously listening for specific sounds, he motions us east, and we head off single file. Humphrey puts his index finger to his lips, indicating we must remain quiet. I scratch my head in puzzlement. Why are we heading east, the exact opposite of the tracks, which point west, parallel to the river? But, trusting Humphrey's skill, I keep my mouth shut. I will ask questions later. Right now we are stalking the king of beasts.

Stalking is slow and requires patience. We travel in single file without speaking and use hand signals to communicate if we need to freeze, which is a challenge in self-discipline and mental control. Every few minutes Humphrey shakes some ash into the air to be sure we are upwind of our quarry.

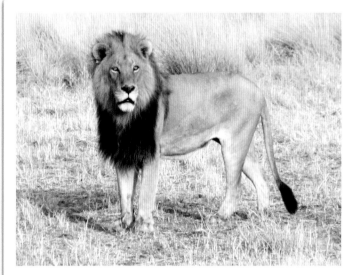

We continue to move east, occasionally stopping to take in views of the landscape and search for signs of animal behavior that would suggest the lions are in the area. We also continue to listen intently. We hear the sound of hooves, and from behind the underbrush appears an eland. This male is so huge it seems like he is on steroids—and it is also evident he is spooked by the lions. Eland often travel in herds of 30-plus, and sure enough, within minutes there are almost that many crossing in front of us, traveling at a gallop. But still no sign of the lions, and we continue eastward.

Time passes and our nerves are on edge, knowing full well that at any time, something may alert the lions to our presence. A startled flock of birds or screaming baboons, for example, could give away our position, so we must be stealthy. We are attempting to outwit survival skills the lions have developed over centuries in a challenging environment, not an easy task. Unlike lions, which have adapted over time to be able to travel for days without drinking water after absorbing moisture from the meat of their prey, we must stop to hydrate, as we have been tracking now for over an hour.

We move on with the thrill of anticipation; our senses are peaking. We are totally focused on our objective and the challenge of stalking this predatory carnivore. Nearby we see a lone sable antelope, a beautiful creature of a deep chestnut brown with a white underbelly, white cheeks, and a white chin, with large, majestic horns that spiral back in an arch. We spot and inspect some termite mounds. Humphrey climbs to the top of one and surveys the area. He see that the lion tracks traverse several streams and are no longer going in one direction, but are scattered about. We've lost our momentum but still have our desire, so Humphrey says he will look for fresh lion scat along the edge of the stream, where the ground is baked hard except at the water's edge. To my surprise, he asks me to check for tracks on the opposite side of the stream, down 100 yards (91 m) or so. It was just this morning that he told me that, with my years of schooling

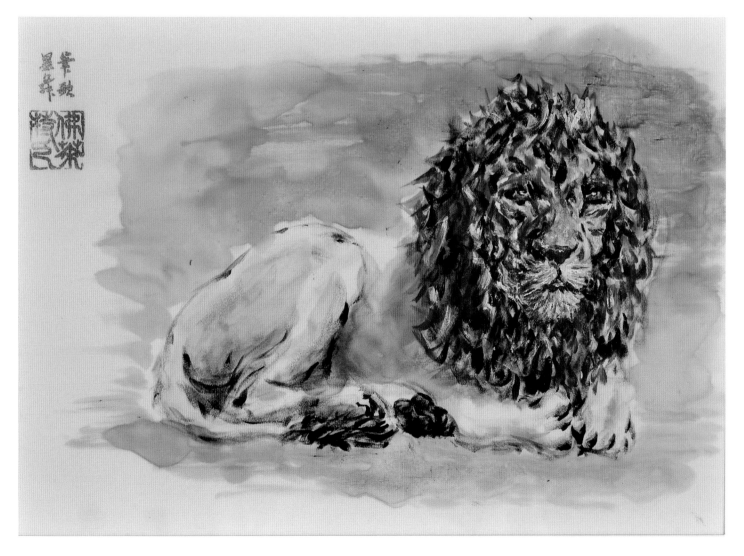

Dye on silk

in the bush, he expects a bit more from me. Now, without questioning my knowledge and ability, he is expecting me to contribute.

Off I go, and within 25 yards (23 m) I find fresh spoor crossing back and forth across the stream, with no general direction. "Have the lions backtracked and are they now behind us?" I ask myself. Humphrey acknowledges that the tracks I have discovered are indeed from the lions, and determines it is best to go back to the last and freshest track. It is his habit to mark the fresh tracks every so often by dragging his foot across the ground, allowing him to easily return to the freshest track and reevaluate the trail.

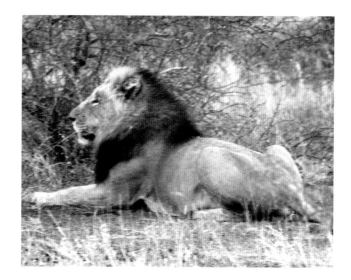

As we approach the termite mound Humphrey had stood on only 20 minutes before, there is a shadow next to it—is it a lion? We hold our position—and our breath—behind some adrenaline grass. A lion's skill at concealment is extraordinary, and now we must conceal ourselves. We wait, peering through the grass, and notice that the shadow next to the termite mound has disappeared. We move slowly and cautiously forward. As we approach the mound, we can see where a lion had lain down at full length in the shade of an acacia tree opposite the termite mound, which blocked our view of our quarry. The imprint of the lion's body and forelegs is distinct, but even more obvious and impressive is where his enormous paws rested on the soft earth. From paw to tail, he stretched out almost eight feet (2 ½ m). We certainly now have fresh tracks, but the lion has moved into the adrenaline grass, where not even the best guides will risk tracking any wildlife, let alone two unpredictable male lions.

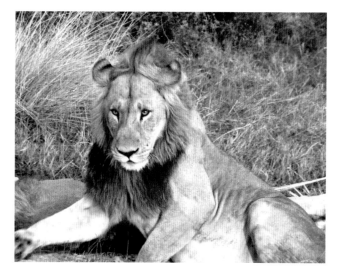

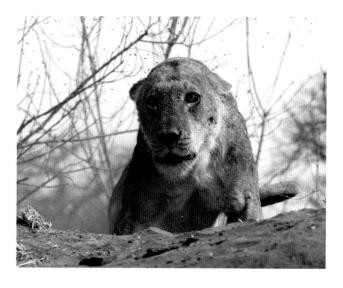

Humphrey chooses to try and pick up the tracks on the other side of the grass, and we move on for another hour until he puts his hands out, signaling us to stop. He slowly motions with palms down to knee. There, about 40 yards (37 m) away in a clearing between acacia trees, is one of the males of the Mana Pools pride. He looks to be about four feet (1 m) tall at the shoulder and perhaps 500 pounds (227 kg); his mane is full and shines lemon yellow with a tint of crimson on the ends. We remain motionless, and suddenly out of the thicket into the clearing comes his brother, head held high and swaggering, his mane glowing a spectacular vermilion and a stark contrast to his light buff coat. He is even larger than the first male, and his muscles shimmer spectacularly in the sunlight.

Fortunately, the lions have not picked up our scent. Humphrey slowly reaches for his ash can and shakes it to check the wind's direction. Good—we are still upwind from these magnificent beasts. The brothers move on. Humphrey looks back and smiles broadly; we follow quietly, realizing once more how walking and tracking in silence truly reveals Africa.

Lions, like every cat, have three lobes at the back of their paws and four in the font. There are no claw marks, because their claws are retractable, unlike those of a cheetah, which has nonretractable claws.

The lion is the second-largest living cat after the tiger, with males reaching up to 550 pounds (250 kg).

The eland, the largest species of antelope, eat grass, branches, and leaves. Though considered diurnal, they can be somewhat inactive during the day.

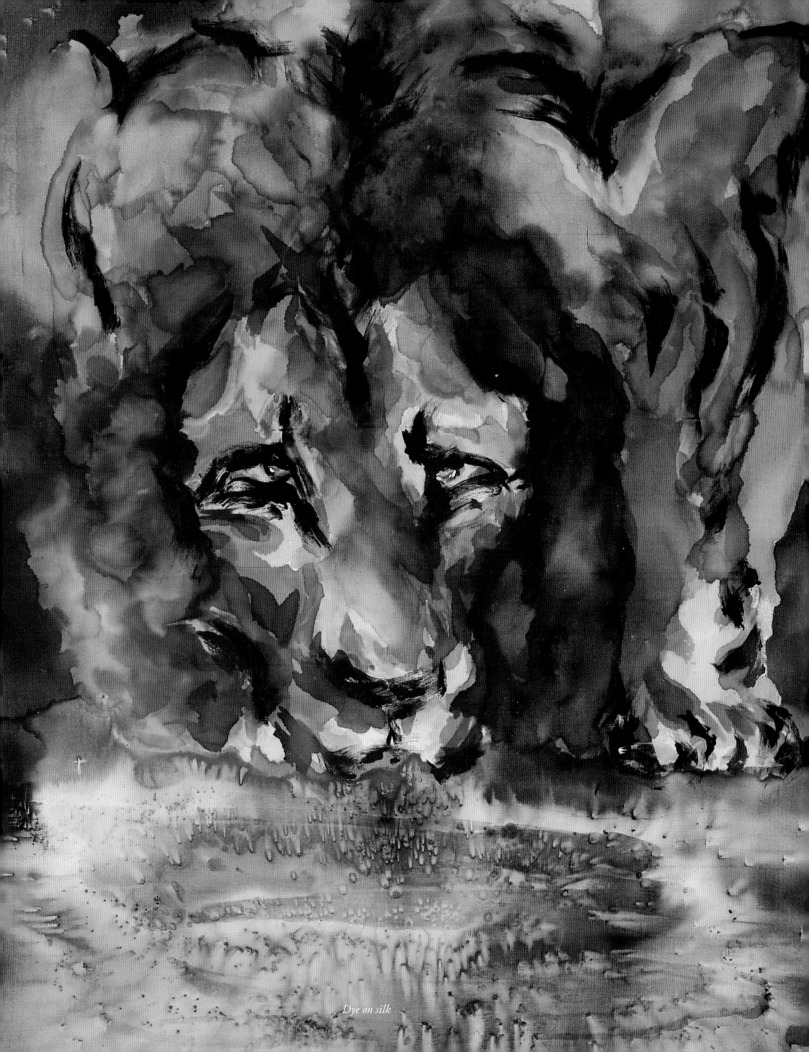

Dye on silk

Sumi on rice paper

We reach the clearing and Humphrey pauses. Again, he gives us the "palms down" signal and we kneel quietly. Ahead in the thicket of feverberry shrubs, the brothers have somehow picked up our scent, perhaps from a swirling bit of wind, and are now looking at us squarely from the underbrush only some 20 yards (18 m) away.

Lions have excellent vision and respond to the actions of others around them. If they spot you, and you lie down on your belly or crawl, they will sit up to get a better view. We are kneeling down and they are camouflaged in the thick underbrush, heads held high and proud. A lion charge is not what we want here, so we are naturally concerned and assess their posture. When a lion charges, his head is low and above his forepaws, his hindquarters arched a bit for maximum spring, his claws dug into the ground and his tail twitching, with an inverted curve. The tails of these lions are twitching, but they do not display the posture of charging. Once again, I realize how a guide's intimate knowledge of the characteristics of animals in the bush is imperative. Just as an elephant's tail stiffening and rising to one side is a sign of aggression, the twitching of the lions' tails here is a sign that we are intruding and we need to stay calm and retreat.

My anxiety level is high, but so is my excitement and adrenaline—this is Africa, after all, full of unscripted adventure. Humphrey puts his finger to his lips and then pushes his hands toward us, palms perpendicular to the ground, indicating we must retreat from the lions facing them, not showing our backs, or we could easily become prey. We crawl backwards with thorns and rocks scraping our knees and hands, but as we retreat we notice with surprise there are cubs in the thicket behind the two brothers. The males were apparently coming back to their pride after a morning jaunt, and we had unknowingly followed them to their family.

After 40 yards (37 m) of backtracking, Humphrey allows us to stand up, and we all take deep, nervous breaths. We look through our binoculars and can see some of the pride, but the underbrush is thick and blocks us from a good view. I sketch a few lines into my notebook, and realize now is an opportunity to ask Humphrey my question.

"Why did we travel east?" I inquire. "How did you know?"

"The baboons," he responded. "The juvenile baboon learns the lion call first and the juveniles were screaming 'lions,' so I anticipated the lions had backtracked to the east."

I shake my head in amazement, realizing there is always something new to be learned in the wilds of Africa.

In the Eyes of the Guide: Incomplete without a Camera

BY HUMPHREY GUMPO

From the day I went on my very first assignment in the wild, life has been eventful, adventurous, and an education of incredible pace and proportions. Recording and writing down all of these experiences would create a real masterpiece—but I was so fascinated by the magic of the African bush and committed to my job of ensuring the safety, education, and enjoyment of my guests on safari that I amazingly never felt the need to record, capture, or document any of these moments.

Left: Oil on canvas

Until, that is, one day at the Chessa Camp on the Zambezi River, a place that had been my "office" for four years. It is the second morning of the Canoe Trail along the Mana Pools shoreline. My mission in the pre-dawn is to have all guests awake, freshened up, fed, and in their canoes before sunrise. While we enjoy our light breakfast, though, unplanned events begin to unfold.

A very distinctive bellow, signifying the death of a buffalo bull, echoes through the acacia forest. I run for my backpack and rifle, which are in the opposite direction of our vehicle, where my guests are quickly boarding. I look at them expectantly, waiting for them to get off this seemingly sacred mode of transport. With my passion for walking and canoeing in the African bush, I had vowed that year to never take a game drive, with the exception of the short drive to and from the airstrip. I am not about to break my vow now. A New Zealand couple looks at me curiously, but as the bellowing continues, they have no choice but to follow their guide and leader.

As we run toward the sound (about a half mile [805 m] from the camp), it becomes more intense, which only makes me move faster. But as we get within 800 feet (244 m) of the sound, I realize it does not tally with the site. I stop and look through binoculars, and see the cryptic-colored coats of a pack of smaller animals surrounding a larger set of horns. I tell my guests, "I have heard of this happening once, and if it is what I think it is, this might be one of our most memorable wildlife experiences. There is a pack of wild dogs around the bellowing buffalo. Let's go!"

We run along the depression of the Mana River, and get within about 300 feet (91 m). I realize that even though the buffalo is still bellowing, none of the wild dogs seem to be in contact with it. But considering this frenzy of excitement from both parties, we have to get closer. It is only when we climb out of the riverbed that we see an amazing sight, one that neither I nor my guests can believe. Six lions are holding down a dark, muddy Cape buffalo, and a pack of about 23 African wild dogs are actually trying to create commotion and save the buffalo, and are doing this at dangerously close quarters to the lions. They are too close, if you ask me, but the dogs seem to know what they are doing. Every time a lioness turns from her task to chase the dogs, the buffalo bellows and wriggles, forcing the lioness to return to secure this hard-earned meal. This game of cats and dogs continues for more than half an hour—which, for the buffalo, probably feels like an eternity—until finally the bellowing stops. The dogs also realize they are fighting a lost cause, and start moving a little farther away from the now less preoccupied cats.

Two of the lions who had just killed this buffalo now turn to look at us, and with the absence of the dog cover, I realize how close we are to them. Their bright gold eyes home in on us. The wild dogs had created a decoy for us, allowing us to get within the lions' comfort zone, something not usually accomplished. But on this day, we are apparently to be forgiven, because of a combination of factors. The lions are tired—in addition to chasing the pesky dogs around for a while, they had also just wrestled a "Dagga Boy," a term for an old, grumpy buffalo bull past his prime, who had left his main herd.

I am not willing to bank on the fact that the lions would not charge just because they are tired, so we back off slowly, returning to the slightly safer comfort of a sausage tree 80 feet (24 m) or so from the lions and their breakfast.

The dogs, for their part, decide to rest under an acacia tree, and we all watch the lions rest a little before they start to devour the carcass. The sun is warming up, and the shade is thinning out under the acacia tree. One by one, the dogs get up and begin to walk in the direction of denser shade, which turns out to be the same sausage tree we are sitting under. This is too good to be true! One after another,

Bronze

more than a dozen of the unique dogs come to share the shade of a sausage tree with us; one sits within 15 feet (5 m) of one of my guests. The dogs are also watching the lions feed, and with our proximity, they probably feel a false sense of security should the lions change their minds about tolerating the dogs' presence. To be honest, the dogs provide that secure feeling for us, too.

Mid-morning, we head back to where our camp had been, only to find canoes waiting for us. My team knew better than to wait for me to return from one of my walks and had decided to carry on and set up the next camp downriver, leaving us with the canoes for the next leg of our journey.

Suddenly it dawns on me that this remarkable morning had come and gone—and even though it is still fresh in my mind, I will never see anything like this again my lifetime. I did not have means to record or capture this awe-inspiring experience.

After this unforgettable day, it wasn't even eight weeks before I was the proud owner of my first SIGMA SD9 digital camera. Much to my surprise, since my first click, it has been an education, and photography has become one of my passions. I am glad I never owned a film camera, however, because with the number of photographs I take, the excitement I get out of trying different settings, and learning when in the company of professional photographers, I would owe a small fortune in developing fees. As it is, the only way I can feed this hunger for photography is to constantly invest in new cameras, lenses, backup devices, and flashes—and thankfully I can declare it all as "work equipment" with the Ministry of Home Finance!

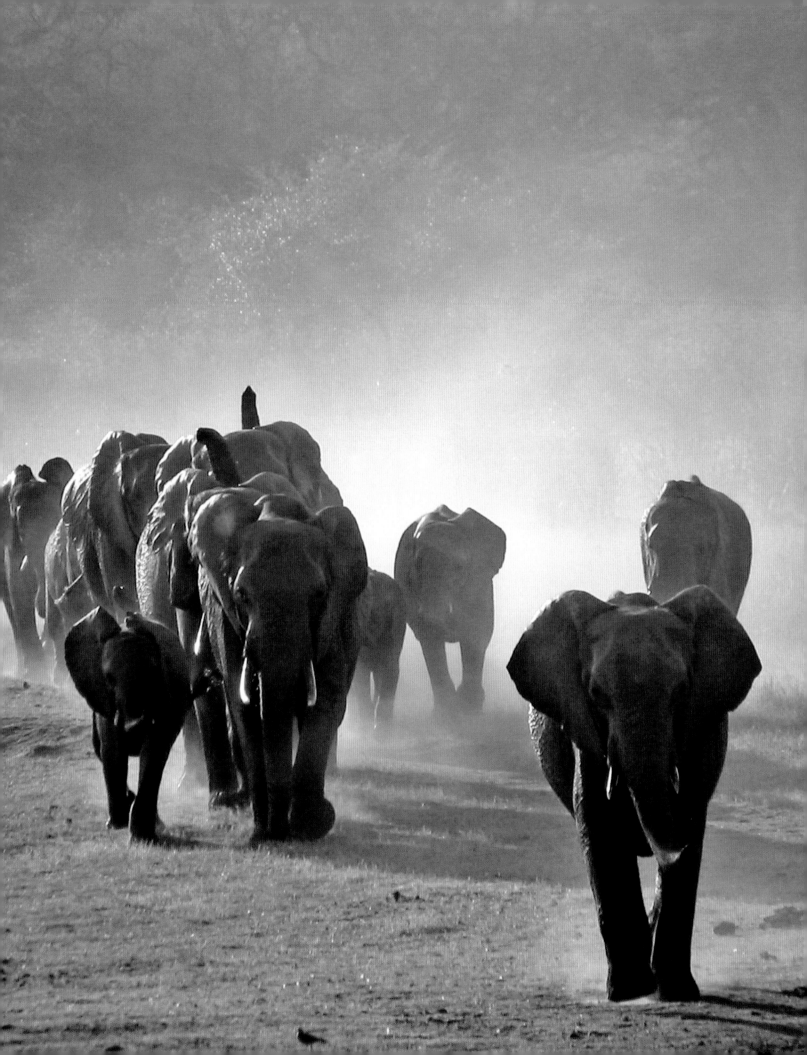

11

Elephant Encounters

BY HUMPHREY GUMPO

A canoe guide during safari season can expect to make around fifty to sixty trips down the river, so it's not at all surprising that during the season guides have encounters with a hippo or two; one perhaps brushing the canoe, another stumbled upon when sleeping, or even a charge that capsizes the canoe.

Dye on silk

In 2003, I did all my canoe trips without a break, and had no contact with any hippos—a perfect season. The last day of the season, I was camping at Ilala and looking forward to an unprecedented period where no guide had any adverse contact with wildlife. I eagerly anticipated throwing my paddle into the Zambezi to celebrate an incident-free record for the year.

The final morning, I depart camp before sunrise—I in one canoe and two guests in another —gliding down a silent channel. Before long, we spot an elephant herd on the Zambia side entering the river. When an elephant swims, it may or may not have its trunk out of the water, but regardless, it considers the canoe simply a part of the water or a part of the scene; they just carry on.

I decide to join these elephants and paddle next to them as they cross the river. It is a herd of about fifteen, including babies, and at any one time there are ten or twelve trunks out of the river. It is an incredible sight to behold at sunrise, needless to say. Midstream, one of the calves drifts away, and there is a bit of panic because it is drifting about thirty yards downriver. One of the adult females leaves the herd to corral the calf.

In the meantime, I notice there is a gap in the high bank of maybe ten feet or so, and assume this is where the elephants will access the Zimbabwe shore. I decide to strategically park our canoes maybe twenty feet upriver from the gap so we can watch the elephants exit the water. Sure enough, the elephants start leaving

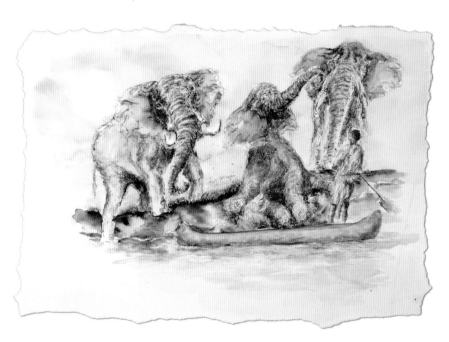

Pen and ink watercolor

the river, taking their time. Before too long, the current has pushed the canoes toward the gap, but the elephants are comfortable, so there are no worries.

There are three cows left, and as the first of these leaves the water, she gives a bit of a mock charge toward the canoes, but continues on her way. Then, from behind her, the next cow decides to give a bit more than a mock charge, placing one foot firmly in the water and leaning forward, putting her forehead against my canoe, which promptly takes on about 50 gallons of water and sinks into the river. Naturally, I cannot steer it or even back paddle, so I have no choice but to jump into the guest canoe and allow mine to drift.

Realizing the guest canoe is now overloaded, I jump onto the bank and pull the canoe from the stern back toward the bank where I stand. All this time, the cow is trumpeting and drawing the herd back to the edge of the river. There are eight elephants standing on the edge of the bank, which suddenly collapses under the weight of one of the large cows, who falls right through the middle of the canoe into the deep water of the channel—almost a 10-foot drop from the bank.

The cow disappears underwater for an instant and then reappears, coming up from the floor of the Zambezi, causing the guest canoe's bow and stern to lift and collapse the middle. The guests jump into the river as I frantically shout at them, "Swim—swim now!" As one guest looks back, the cow's eye is level to his when she resurfaces from the floor of the river. With looks of extreme fear, both guest and elephant swim back to the gap at the bank, where the cow exits and the guest stands next to me. The other elephants trumpet and storm about above us.

We humans are now all standing on the bank under the herd, and I order everyone into the water, fearing the bank will collapse again under the extreme weight of the entire herd. We tread water for a couple of minutes, but I realize there is greater danger in the water from crocodiles, so I instruct the guests to swim to the gap where the elephants had exited the river—but there is a shortage of space, because the cow with the errant calf is approaching the gap, I do not have my rifle, which is drifting next to the cow, who is now coming up onto the bank. I face her, confronting her mock charge, but just as I am about to jump back into

the water, she stops. I reach for my rifle, unzip the case, load a round, and fire a warning shot into the air to disperse the herd. It is in the nick of time. The cow retreats, gathering the calf and swimming downriver to the next gap to join her herd.

A bit of the bow of the guest canoe drifts by in front of us, and I jump into my canoe, which was ripped apart near the center and is still filled with water and non-navigable. I reach out for the bow of the other boat, expecting to hoist the canoe up, but pull up only four feet. I follow the rest of the canoe, expecting to pull up the remaining fourteen feet, but only another four feet appear; I suspect the canoe was shattered by the weight of the elephant in the center, leaving only four feet of the bow and stern.

Needless to say, my dreams of a "perfect season" were shattered, and I never did throw down that paddle.

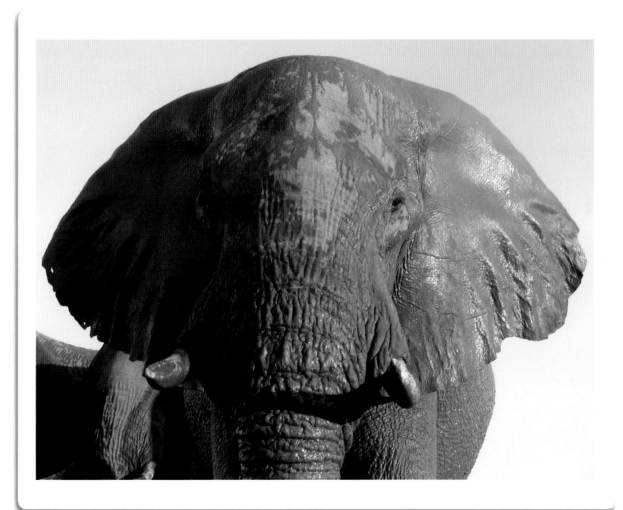

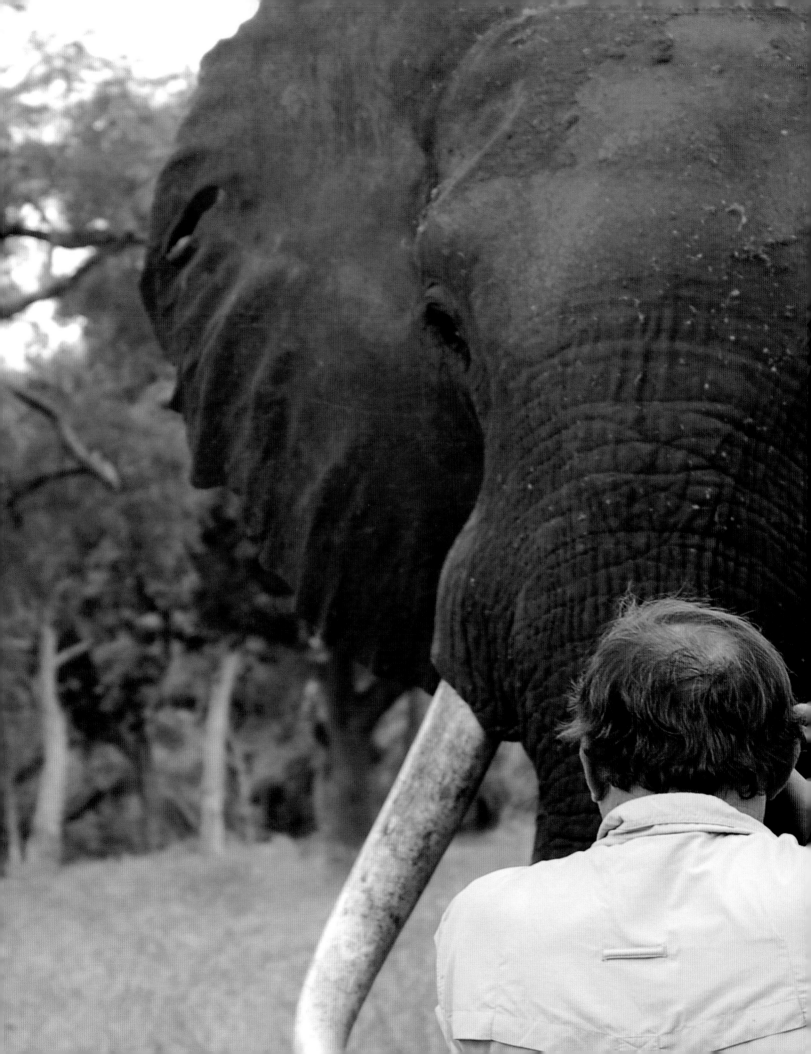

12

Feathers and
Fables

While many first-time visitors to Africa come to see the proliferation of wild mammals on the continent, they are often surprised and charmed by the equally abundant and fascinating birdlife. Nearly 2,500 species of birds have been seen in Africa and on its associated islands. And we're not just talking about boring little brown or black sparrows and starlings, either. Many of the birds of Africa have been painted with nature's

Left: Oil on canvas

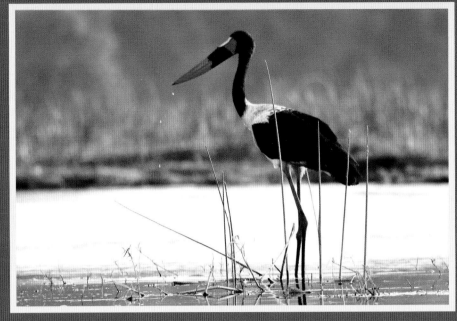

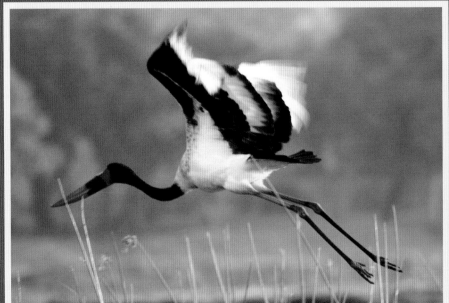

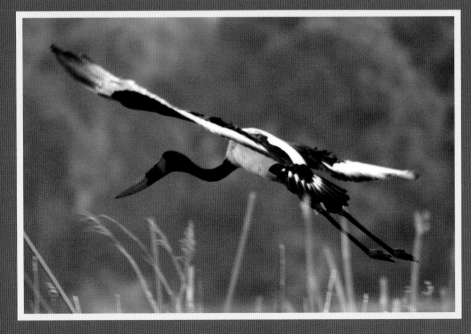

Saddle-billed stork

most brilliant palette of colors: lush emerald greens, carmine reds, iridescent blues, and lemon yellows. There are tiny shimmering sunbirds, similar to the hummingbirds of North America; bright blue kingfishers, hovering near rivers in hopes of catching a small fish or two; clever weaver birds, whose intricately constructed nests dangle from many an African tree. Safari-goers become accustomed to awakening to the distinctive calls of the francolin and the guinea fowl, which cut sharply through the morning mist and are infinitely preferable to a jangling alarm clock.

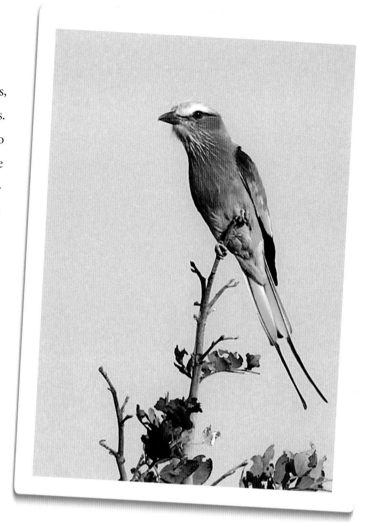

Although I am admittedly not much of a "bird person," two species in particular catch my eye. One is the relatively common lilac-breasted roller, a stunning blend of blues, lilacs, browns, and greens. Usually seen alone or in pairs, these beautiful birds often perch conspicuously on the tops of bushes or trees. Profuse throughout eastern and southern Africa, the lilac-breasted roller is Botswana's national bird, but it is also revered in Zimbabwe for a very special reason.

One day in a village just outside Zimbabwe's Hwange National Park—the largest game reserve in the country—I sat down to work on a charcoal sketch of a leopard we had tracked and spotted earlier that day as it lounged lazily on the limb of an acacia tree. Before long, a young village girl approached me and peered shyly over my shoulder as I sketched, her eyes carefully watching every stroke of the charcoal. Somewhat to my amusement, she placed her hand to her mouth when I use my kneaded eraser, apparently afraid I was about to make the entire leopard disappear before her eyes. Her engaging gaze and obvious interest compelled me to offer her the sketch as a token of my appreciation for her patience while watching me at work. Her eyes shone brighter than the sun in gratitude. She disappeared with my sketch in hand, smiling, but soon returned with four lilac-breasted roller feathers, which she presented to me as a thank you for the drawing.

She then told me the history of King Mzilikazi (meaning "The Great Road"), who ruled what was then known as Rhodesia from 1823 to 1868 and founded the Matabele kingdom. The girl spoke of Mzilikazi with great reverence, and quietly told me that she, in fact, is a

descendent of the great king. David Livingstone, in his autobiography, referred to Mzilikazi as the second most impressive leader—next to the Zulu king, Shaka—that he encountered on the African continent. Naturally, many of Zimbabwe's Matabele tribe still consider him to be the greatest South African military leader ever. These feathers, she said, had been passed down to her from her great-grandfather, who believed no one in her country could hold them other than a king. I accepted the feathers graciously, wondering if this story was true or merely a fable passed on at bedtime.

Several days later, I found myself in the town of Bulawayo, where there is a museum dedicated to the history of Zimbabwe. To my great interest, I came upon a writing from King Mzilikazi himself, indicating he was so enchanted with the lilac-breasted roller he decreed that only he and future kings could adorn themselves with these brilliantly colored feathers. I felt greatly

honored to have been bestowed this symbolic treasure from such a charming descendent of the renowned king.

On another fine African day, Humphrey and I are tracking along the Zambezi River in a forest of mopane trees. The sun is shining bright; its rays break through the canopy, reflecting off the leaves and showcasing the colors of the forest: darker emerald green and brighter yellow-greens, creating shadows of bluish-green viridian blended with subtle earth tones.

Suddenly, the forest darkens, as if there is an eclipse of the sun. I look up to witness a large winged bird—a prehistoric creature come to life—swooping over us silently, like a stealth bomber, its wingspan

engulfing the canopy above and shutting out the sun's rays. The giant bird is so quiet that not even Humphrey is aware of its presence until daylight disappears. The underside of its body is colored a zinc white mixed with burnt sienna and a bit of crimson, with touches of burnt umber noticeable as the wing feathers stretch out. The wings themselves look to be horizon blue, blended with a touch of light green and white.

"This," says Humphrey, "is a Pel's fishing owl, and it is very rare to see, as its habitat is limited and it is largely nocturnal." After the impressive bird passes over us, it perches in a tree across the channel—a favorite perch from which to seek out its prey, including fish (weighing up to four pounds), frogs, crabs, mussels, and even young crocodiles. I can glimpse the owl's outer feathers now: tawny earth tones with random spots of dark burnt umber.

We wade across the shallow water to seek out a better observation point. Through my binoculars I can see the bird's enormous pearl-colored talons, which extend around the branch; these long claws, combined with its spiny feet, help hold its slippery prey. Despite our own efforts at stealth, the owl senses our presence, and, in silence, stretches its wings and takes flight. Several of its feathers fall to the base of the tree trunk onto the forest floor; the few soft remnants we find are absolutely weightless, no doubt contributing to its furtive characteristics. Aptly nicknamed "The Leopard with Feathers," it reminds me once again of the many surprises to be found in this amazing land.

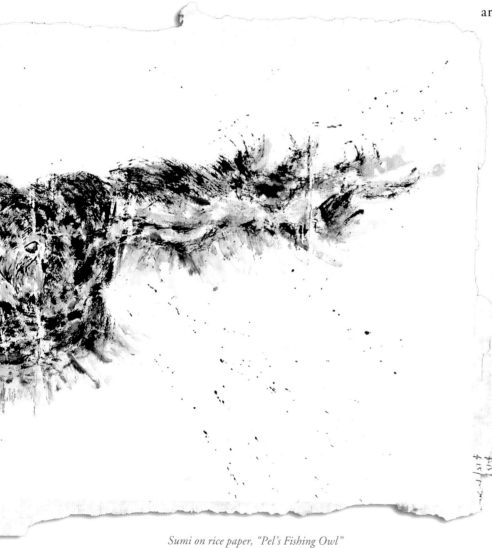

Sumi on rice paper, "Pel's Fishing Owl"

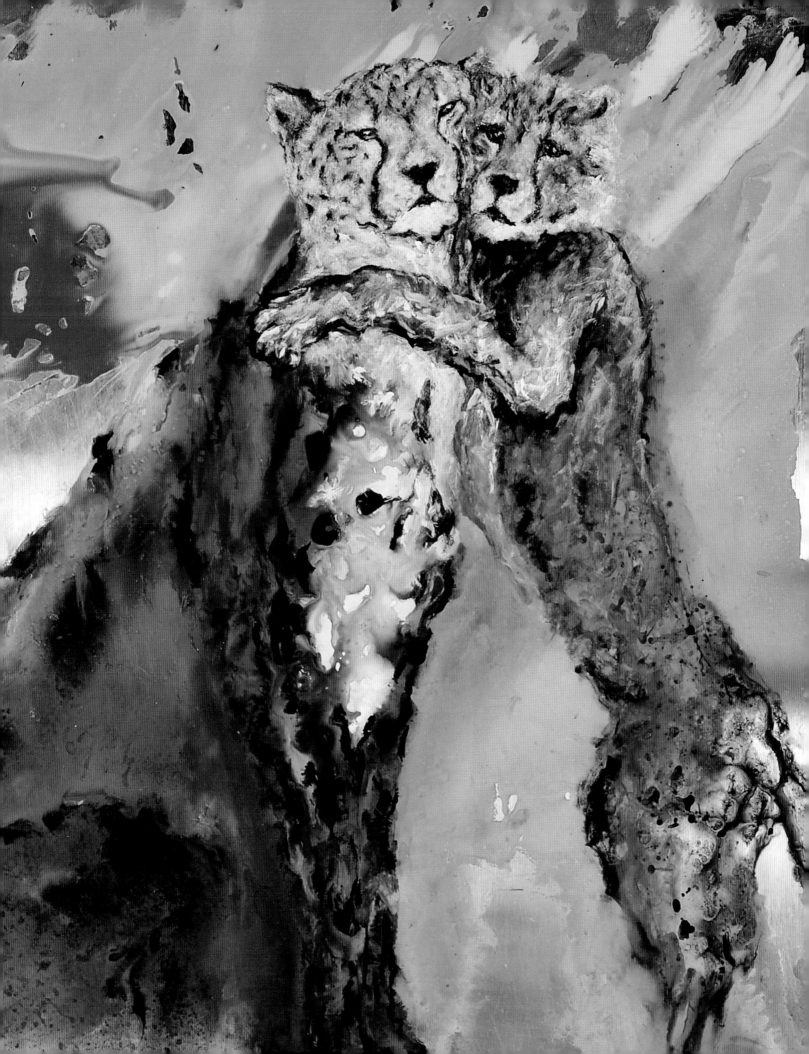

13

Africa's Graveyard:
The Leopard's Lair

Some days on safari you simply wake up and began meandering through the bush in search of adventure, and this was one of those days. We pass several of the more common wildlife prospects in the Okavango's Moremi Game Reserve— zebras, impalas, and giraffes—but then off in the distance we spot an outcropping of boulders and rocks with dense scrub brush. Although our binoculars show no signs of wildlife, we nevertheless choose to investigate.

Left: Oil on copper

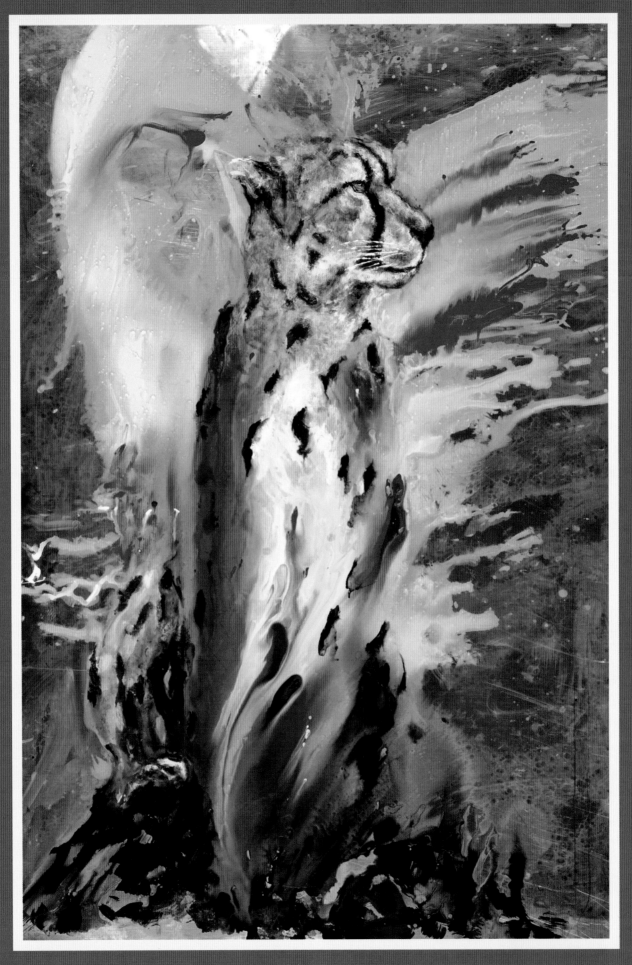

Oil on copper

Our guide leads us single file through the knee-high grass and we climb over the rocks to the outcropping's center. We push through the brush and come upon the scene of what must have been a brutal confrontation. There is shredded hide in various textures and colors, ranging from coarse gray to vermilion, thrown about as if a rag doll had been ripped apart and discarded haphazardly. Pieces have even been violently tossed onto the overhanging lower limbs of a camel

thorn tree. I immediately notice a partially buried skull, wedged between two boulders under some scrub, alongside what appears to be a rib. I carefully dig around the skull and then lift it, revealing what creature came to an untimely end in this thicket: a baboon.

Nothing is certain in Africa, but I can only assume this is a "graveyard" of sorts—a leopard's lair. I immediately flash back to a previous experience at Thaba Lodge in South Africa, where, while tracking a male kudu, my South African guide, Mark Ivy, and I found a similar scene next to a kopje (a small, rocky hill on the African veld, pronounced "koppie"). After pushing through the scrub brush and climbing over good-sized boulders to the center of that particular outcropping, we initially spied a stark white skull partially showing under the bent grass. The skull was connected to a partial spine, and the lyre-shaped ridged horns of the impala were still intact. Additional evidence was a handful of vertebrae scattered about, some broken ribs, another smaller antelope skull (its short, round, spiked horns obviously those of a duiker), some warthog tusks, and pieces of waterbuck hide.

Mark was as skilled as a forensic surgeon as he investigated the area, eventually uncovering a small shelter—a den—hidden beneath an undergrowth of grasses in the rocks, where there were many smaller fragmented bones, distinctive helmeted guinea fowl feathers, and burnt reddish francolin feathers. He interpreted all the evidence to conclude this was the lair of a leopard and her cubs, especially considering the bone fragments in and around the small den, which certainly was where the cubs would have been sheltered.

The most compelling evidence to confirm this theory was the discovery of the heads and partial skeletal remains of half a dozen goats. The closest farm with domestic goats was more than three miles to the east; it is hard to believe that a hungry leopard would drag one goat that distance, let alone six that weighed close to 60 pounds (27 kg) each. A leopard kills by biting its prey on the throat or the back of the neck, and then has been best known to haul its kill—up to three times its own weight—into a tall tree, lodging it in the branches so as not to draw the attention of ground scavengers such as hyenas and jackals. This female leopard was on a survival mission to feed herself and her cubs, and was prepared to risk the scavengers of the land.

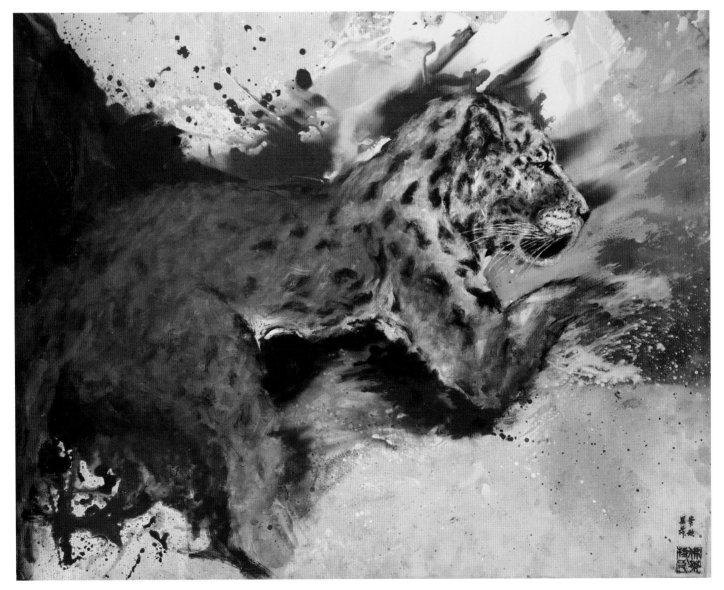

Oil on copper

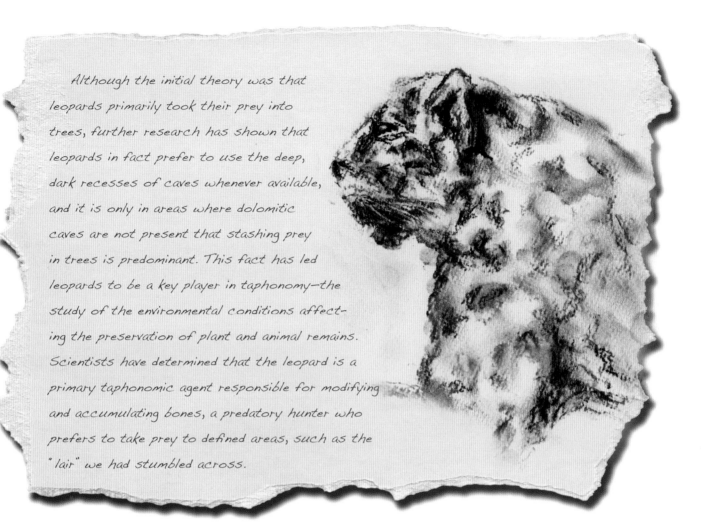

Although the initial theory was that leopards primarily took their prey into trees, further research has shown that leopards in fact prefer to use the deep, dark recesses of caves whenever available, and it is only in areas where dolomitic caves are not present that stashing prey in trees is predominant. This fact has led leopards to be a key player in taphonomy—the study of the environmental conditions affecting the preservation of plant and animal remains. Scientists have determined that the leopard is a primary taphonomic agent responsible for modifying and accumulating bones, a predatory hunter who prefers to take prey to defined areas, such as the "lair" we had stumbled across.

Mark's willingness to allow me to study the fascinating scene with him, and share the findings that concluded this was the lair of a leopard with two cubs, is a testament to his guiding knowledge and patience. Although these leopard lairs are rare to uncover, now I—faced with somewhat similar, albeit much less, evidence once again—deduce that this is another leopard's lair, even though the exhibits are certainly not as compelling.

The site of today's explorations—the Moremi Game Reserve, at the heart of the Okavango Delta—was once the principal hunting ground for the revered Batawana Chief Moremi, and it is thanks to his efforts that this land was set aside and protected for future generations. Today, it is wildlife like the leopard that flourishes as hunters here. We move on, hoping to perhaps find, around the corner, the hunter responsible for this "cemetery" we've stumbled across. Through our binoculars we sight two cheetahs, and it appears they are stalking a Thomson's gazelle, a beautiful, cinnamon-colored little creature with ridged horns curving slightly backward, a white underbelly, a rich dark chocolate racing stripe running along its rib cage to its flank, and a black tail that is always twitching. We choose to watch from a distance, so as not to interrupt Africa at its finest.One of the longer-reigning twosomes in the Moremi Game Reserve was nicknamed "The Steroid Brothers," who, guides tell me, ruled for more than nine years. It is said, however,

that for the best success, three is the magic number for a cheetah coalition, and a locally known cheetah group humorously nicknamed "The Three Amigos" fit this billing.

The two cheetahs we now observe have coats of gold overlaid with black spots and a burnt sienna undercoat. Their white chests are touched with a hint of light horizon blue, but all the colors blend easily into the background vista of burnt umber mounds dotted with viridian and sienna grasses. The two cheetahs suddenly separate and are several meters apart. The one closer to us stops with his head held just above the tall grass, while the more distant feline is crouched, camouflaged into the landscape, undercover. They are so still they appear to be statues, making slow, deliberate moves with great patience. The gazelle does not have any idea that in a short period of time, he will be using his speed and sharp hooves to make razor-edged turns in an attempt to elude his predators. Meter by meter, the cheetahs draw closer, increasing their probability of a meal while astutely watching every move of the gazelle to avoid being discovered.

As we watch in anticipation, the gazelle lifts its head. Simultaneously, the near cheetah explodes into action, but the gazelle is quick and has a good lead. Amazingly, he outsprints the world's

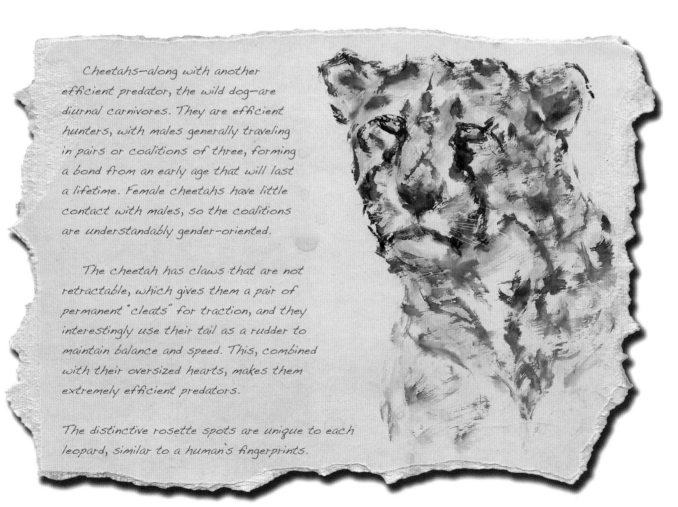

Cheetahs—along with another efficient predator, the wild dog—are diurnal carnivores. They are efficient hunters, with males generally traveling in pairs or coalitions of three, forming a bond from an early age that will last a lifetime. Female cheetahs have little contact with males, so the coalitions are understandably gender-oriented.

The cheetah has claws that are not retractable, which gives them a pair of permanent "cleats" for traction, and they interestingly use their tail as a rudder to maintain balance and speed. This, combined with their oversized hearts, makes them extremely efficient predators.

The distinctive rosette spots are unique to each leopard, similar to a human's fingerprints.

fastest land animal, avoids the ambush, and escapes. The cheetah nearer to us terminates the run almost immediately, knowing he has been outwitted—this time. He stands there, breathing heavily after his short wind sprint, and is joined by his brother. The cheetahs pause for a moment; one then climbs to the top of an abandoned termite mound and looks out toward the north for a second chance, perhaps before nightfall. His brother sits nearby in the tall grass, masked in the dense brush and peering out to the horizon.

We now travel west toward a mopane woodland, where the thick branches of enormous trees arch out gracefully. Unexpectedly, right on the edge of the forest above us is a truly majestic

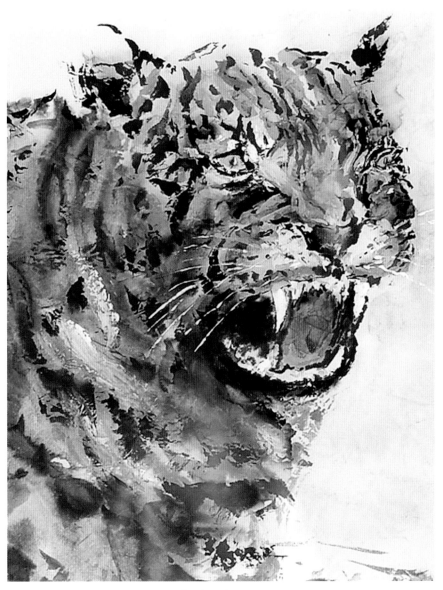

Sumi on rice paper

sight: a spectacular male leopard with his head held high and proud, his chest puffed out, his right paw tucked under his chest, and the left paw stretched out in front of him. The pattern of his ebony rosettes over the deep cadmium-orange undercoat blends into the mopane woodland; it is no wonder these beautiful creatures are so difficult to spot in the wild.

This leopard's coat is magnificent and shines as it catches the sun's rays breaking through the tree canopy. I can see that his eyes are an intense light yellow ochre, but he does not grace me with even a glance, preferring to keep his gaze toward the horizon, hoping to spot his unsuspecting next meal. We watch him in silent awe as dusk draws near, but reluctantly we have to leave this fabulous creature to head back to camp, where tales of the day's adventures will unfold before the warmth of a crackling campfire.

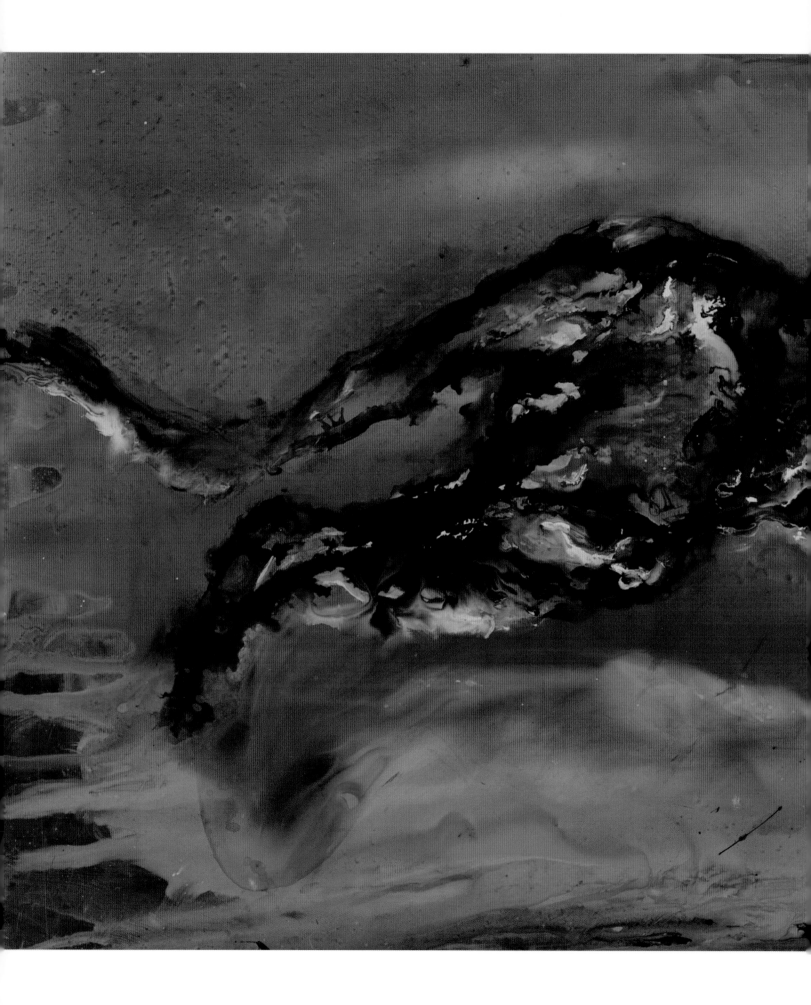

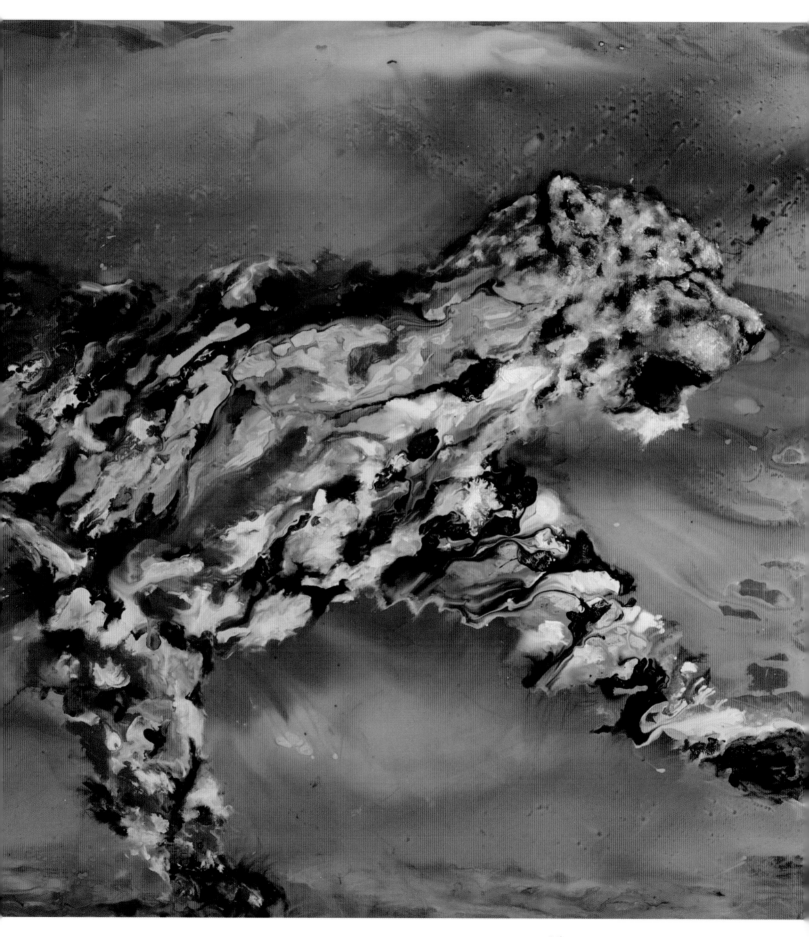

Oil on copper

14

In the Eyes of the Guide: Discovery

BY MARK IVY

IT IS AUGUST 2009, DURING A TRIP JUST

north of Polokwane in South Africa. I was guiding a group of

clients from Arizona—one of whom was Fred—and we went

to investigate a report from one of my rangers that a dwell-

ing of some sort of animal had been identified next to a kopje.

When we arrived, it was apparent that it was a leopard's lair. I subsequent-

ly went back on several occasions with different people with differing

Left: Impala horns

Baboon skull

tracking skills, and then started talking about it to friends and colleagues who are in the same line of work. Our low-level bush-type forensic investigation led to some interesting conclusions.

The site was in a densely vegetated Rhus forest next to a kopje and off the beaten track. There was old evidence that warthogs used to occupy a network of holes to one side, and the leopard had used these holes—and the thick cover of the trees next to the kopje—to establish a lair, where the leopard had given birth to and raised some young. We estimated the leopard family had left this site about a week or two prior to our arrival, so the physical tracks of the leopard were not all that clear, but were still evident.

On arrival, I asked my group to be extremely careful where they stepped—to avoid bare soil and just keep to the grass around the site. We did not stay long at this first visit, and our investigation was not all that comprehensive, but from the evidence we saw, we concluded this was the lair of a mother leopard and at least one cub. We saw a few tracks, large and small, and evidence that the warthog holes had been used by the leopard as a hideaway. She had also hollowed out a patch in the dense vegetation against the kopje. Various body parts of different animals were present. The analysis of these signs, and the ensuing discussion, helped build the leopard conclusion, but it was not to end there.

Warthog skull

I later returned to the scene with my team of trackers: David, Wilson, and John. We scanned the area very carefully and started to build a more complete picture. We found that a few larger trees had claw marks on them, and marking territory and sharpening claws is typical leopard behavior. Secondly, we took inventory of all the body parts on the scene:

- Domestic goat horns, skeletal remains, and bits of hide, from six to eight goats

- Warthog tusks from two warthogs

- A duiker skull

- The skull, horns, back leg bone, and hoof of an impala

- A piece of skin from a young waterbuck

- Various bird feathers, of which we could positively identify only three types: francolin, red-crested korhaan, and helmeted guinea fowl

It made sense that we were finding only pieces of larger animals, which would not be entirely consumed by leopards, while small animals like hares, monkeys, mongooses, tuskless warthogs, and hornless young animals like duikers and steenboks would be consumed completely and leave no remnants. It became apparent that what we were finding was only the tip of the iceberg.

It is interesting to consider in more detail the remains of one of these types of prey, the domestic goat. Remember how I mentioned that it helps to know the lay of the land in order to make a decision about a certain tracking experience? The nearest domestic goat herd that could have supplied this leopard with six to eight goats was three to four miles away. In my opinion, this was

Cape buffalo carcass

one of the main indicators this was the lair of a leopard with young, because why would a leopard drag a goat this distance if it was just for itself? This leopard obviously had some young to feed. Keep in mind we found remains of only six to eight goats; more hornless ones could have been caught and taken back.

We also found feces scattered around in a few places. This feces had the

characteristic leopard look, smaller than that of a lion. Leopard feces also has hair from its prey in it, which is very characteristic of a cat.

Based on our findings, the size of the lair, and the various tracks found around the area, we decided the "mama" leopard had two young ones. A while later our suspicions were strengthened when, in a nearby riverbed with a clay surface, we found a beautiful set of large leopard tracks and then, following behind and next to them, two sets of smaller tracks. True, these tracks could have been from another female with cubs, but we didn't think so, because this area of South Africa doesn't have a high concentration of leopards, as it had gone back to its natural state only within the last 12 years (it was previously a cattle ranching area and with no leopards present), and leopard mothers will usually challenge any invaders that come into her territory.

Cape buffalo skull

15

Art: A Universal Language

WHILE MANY PEOPLE TRAVEL TO AFRICA

to experience adventure and see prolific wildlife firsthand,

you can't come away from the continent without also having

lasting memories of the friendly people here, and the realiza-

tion of how incredibly poor so many of them are. You can't help

but be concerned for the future of the children in particular. Writing a

check is an easy way to relieve yourself of the responsibility of helping the

impoverished children of the world, be it in Africa or on another continent. As for me, I choose to be an ambassador of sorts and personally share my art talents with the enthusiastic youngsters in this part of the world.

Wherever I go in Africa, I work with my guides to locate villages of underprivileged children—not hard to find—and then coordinate with them on what art supplies to bring along. Every child has an imagination, and helping bring that out and teaching children to share their individual imaginations with others is extremely rewarding. There are only happy mistakes in art, and because laughter is great for the soul, humor is an important element to each class, just as humor has been an important part of my life. This, coupled with assisting the children to open their minds to the wonderful world of art, is gratifying beyond description.

"Art is a universal language and needs no interpreter," says my guide, Amon, when I express concern that the children of Rwanda's Mwiko village, who speak Kinyarwanda, might have difficulty understanding me—and I them—as we head over to introduce the youngsters to the world of art.

Just hours before, I had wanted to exercise a bit and decided to go on a run through the rural area of the village. Soon I was being followed, like the Pied Piper, by a number of children, one with a soccer ball that had certainly seen better days.

"Muraho," I said, a greeting meaning "hello"—one of the few Kinyarwanda words I knew. Amon coached me that this would be accepted with a smile by anyone, but it turned out to be a mistake on my

part, because the children quickly responded in their language, which was totally unfamiliar to me. I did the only thing I could: I smiled. I soon became involved in a friendly game of charades, eventually learning a few more of their words. For instance, the children pointed to the nearby volcanoes, and after I started jumping around and scratching my underarms, they mimicked me, laughing and shouting out "ingagi!"—and I now understood the word for gorilla. When I started beating my chest in unison with them, I discovered the word for chest beating is guhonda.

Now, as I head to the area set up for me to teach, I am really excited, having already connected with several of my classmates. Amon thankfully has provided me with three more valuable words: gusiga irangi (painting), byiza (good), and murakoze (thank you).

The children all sit down on the lush green lawn on top of the mountain where the lodge at which I am staying is situated. They have walked a number of miles to get here over a road on which many of us would be reluctant to drive an SUV. It is afternoon, and the reflection of the overcast sky in the distance throws a blanket of violet and indigo hues on the Virunga volcanoes in the background. The chalkboard provided for me is thin, but we are able to stand it erect. We pass out sheets of cold-press watercolor paper, colored pencils, and sharpeners. No erasers, because trial and error creates lines with energy and creativity. We then pass around two photographs: an elephant charging and a cheetah sitting proudly upright on a termite mound. The children unanimously choose to draw the elephant.

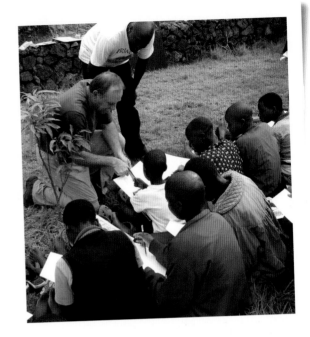

My goal is to share with my young students the richness of the visual experience they can capture with their drawing, and an elephant is the perfect choice, if for no other reason than that they have all "experienced" an elephant. My greatest challenge is teaching them not to copy the shapes I draw on the chalkboard, but to create their own, and to treat the drawing as a puzzle, putting various shapes together to construct an elephant.

The children set to work as I go to every one and, with Amon at my side for needed interpretation, provide encouragement using my limited vocabulary. "Byiza" (pronounced bee see), I say, and receive in return a very large smile. One of the students has nothing on his paper because he is using the butt end of his colored pencil. "Amon," I said, "please ask why he is not drawing with the leaded end." The young man replies, "I do not want to ruin this good paper with my bad art." I reach over and pick up a second sheet from my portfolio and say, "Then use this sheet of paper for practice, and take that one home!" The smile on his face is brighter than the sun.

It has been a long day, and before long I am exhausted. I look over to Amon and suggest we bring our session to a close, but, with a smile, he faces the children and says, "Cheetah?" The youngsters all begin clapping with such enthusiastic energy that I cannot refuse. So now we go about drawing the cheetah, with me showing them how to draw the larger shapes first and then the smaller shapes inside the "puzzle." As before, I make sure to visit everyone in the class and reward each student with encouragement.

As the sun sets behind the mountains, my energy level also disappears, because at dawn that morning I made a short trek up nearby Sabyinyo volcano to visit the silverback gorilla group there, then accomplished

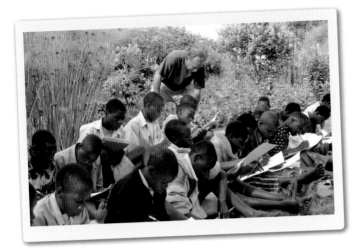

a two-mile run, and now have my afternoon class with the children. I am toast. But then these wonderful children stand up and begin clapping and chanting rhythmically. Two of the young men jump out and begin dancing, their high steps measured with a bit of a shuffle, and they occasionally raise their knees while bending over and then stomp their feet to the ground, their arms outstretched with even their fingers moving to the rhythm. Amon whispers, "This is their 'thank you'—it is a dance where there is a leopard and a hunter following his spoor. Please enjoy!" It is very emotional and rewarding to me, and trying to hold back the tears is difficult, but I do just that: enjoy.

Teaching the children of Africa is absolutely gratifying, which is why I insist a visit to a village to share my gift of art be a part of every one of my safaris. In turn, I am always honored with a tribal dance or chant from the children, or both. It is an incredible experience.

When I visit the Makgato tribe in northeastern South Africa, not only do they sing before the art schooling, but also afterward—the rhythmic sound of the music enhanced by the lapa (thatched roof) at Thaba Lodge, where the class is held in the shade of a large mountain fig tree (whose fruit is edible, but not all that palatable), itself in the shadow of a kopje.

Here, shup shup is the phrase for "good," and to indicate "very good," you add a bit of sign language—a clenched fist with your thumb up. As I observe my students, giving the thumbs-up as much as possible, I notice one of the girls is making very short strokes with her colored pencil, and wonder why. My guide, Mark, acts as my interpreter and translates to me that she does not want to make a mistake, because they may be graded on their art. So I encourage her, explaining that the hardest thing about drawing is the beginning, so it's best to start by squinting your eyes and drawing the largest shape you see. Soon everyone in class is squinting and laughing.

Visiting the children in African villages always has an educational element for me. I am learning their language, their customs—even how long you hold a handshake matters—or their past history, as is the case when I visit the village of Mataposa in southern Zimbabwe.

As we enter the village, we are met by Chuma, a member of the tribal council, who, along with my guide, Maxwell, acts as translator. Because we come

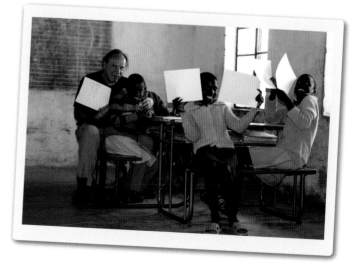

bearing gifts of art supplies—including cold-press watercolor paper, colored pencils, sharpeners, and erasers—we are elevated to a position where we are allowed to visit sacred boulders where shamans once saw visions. We climb between massive boulders—with circumferences of 20-plus feet (6-plus m)—stacked on top of one another, and proceed to weave our way through the caverns created by the boulders to a cave of sorts with two openings on opposite ends. There, at the base of three of the large boulders, are paintings of the San Bushmen, who long ago abandoned Mataposa.

History places the San Bushmen at the root of the human tree, and their art is the oldest known ritual art in the world. I am overwhelmed. Right in front of me is an elephant with its trunk extended and ears drawn out, in a paint of a reddish hue, which I learn was the most durable color for the Bushmen. Maxwell tells me this paint was derived from red ochre (iron oxide), which was ground to a fine powder before powerful substances, such as elephant or hartebeest blood, were added to make each image a repository of tremendous potency, which created these spiritual and hallowed sites.

Our hosts tell us of how Zimbabwe history relates that the elephant and hartebeest held spiritual significance for the San Bushman, whereas in South Africa, the eland held the greatest spiritual potency. The boulder to our right is clear evidence of the spiritual significance of the hartebeest. Again in red, we see a hartebeest with two hunters, each armed with a bow and quiver, holding arrows (no doubt with poisoned tips). The hunters are drawn connected to the hartebeest, undoubtedly to absorb its supernatural potency. The artist must have used his fingers to apply the paint and created fine lines with artist tools of that period, probably either porcupine quills or thin bone fragments.

The boulder near the end of the cave shows the San Bushmen in what is termed "the great dance," where they harness spiritual prowess and use this power for hunting and healing. The animals depicted with the dancers are specifically selected for their potency and, explain Chuma and Maxwell, the hartebeest in the forefront accentuates its position in the world of spiritual potency. San Bushmen value open-ended stories, and so ended my education about the San Bushmen of Zimbabwe, as Chuma says it is time for us to leave this sacred site.

This experience, however, did fill in a piece of a puzzle from my earlier safari down the Zambezi River, when one of the porters for our group asked me to create a sumi painting for him of a very powerful, potent animal, the nzoh (pronounced zo), the Shona word for elephant!

One of the great joys of Africa unscripted is stumbling across something completely unexpected. One day, as we are tracking lions along the Zambezi River near the Nyampi Camp, a rare pangolin crosses our path, heading for the brush near his termite mound den. He disappears when he becomes aware of our presence, but immediately afterward Humphrey is beside himself with excitement. What a rare and fortunate sight this is!

The strange-looking pangolin is similar—although larger—to North America's armadillo. The two animals were at one time classified together, though it is now thought by many experts that the closet living relatives of the pangolin are the Carnivora. Like the armadillo, the pangolin rolls into a ball to protect itself. The toothless pangolin's body is covered with an armor of scales—made from the same protein that makes up human hair. Our sighting was truly special, because the strange creature is decidedly nocturnal, spending most of each day curled up in its den, which is usually within reach of water.

But the real surprise comes when we arrive back at camp. My porter friends go absolutely ballistic and continue to articulate all night about how lucky I am. Apparently legend dictates that the one who finds the pangolin is very lucky! I appreciate their excitement, but I feel lucky every day, every minute, I am in Africa.

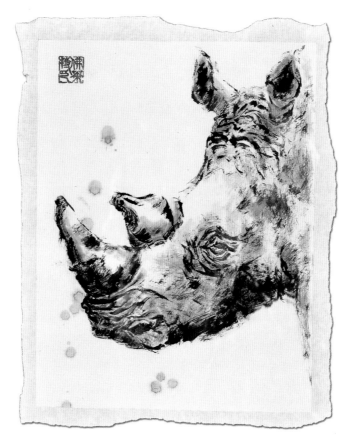

I hope you've enjoyed this tapestry of Africa—as seen through my artist's eyes, as well as through those of two men who are privileged to call this beautiful continent home, Humphrey Gumpo and Mark Ivy. To be honest, the sheer beauty and excitement of a safari can never be truly captured in words or on canvas. It must be *lived*, something I wish every person on Earth could experience. If you've been to Africa and witnessed these creatures, let them thrive in your heart. If you have not, I hope the words you've read and the art and photographs you've seen on these pages have moved you—that they have helped you understand how important it is that we preserve this incredible place and its creatures, and that Africa has taken a place in your heart.

Indeed, Africa is a complicated country with problems and issues hard for foreigners to comprehend, but with tremendous gifts to the world. This book is my gift to Africa. It pays homage to both the magnificent animals of the continent and those who work to protect them—the guides, the conservationists, and the scientists, such as Dr. Laurie Marker and the Cheetah Conservation Fund. Please share this book with others, tell the stories, dream out loud of visiting once or coming home again. In this way, together, we can work to preserve the wonder of this continent and all its creatures.

Reading the "Bushveld Newspaper"

B Y M A R K I V Y

Growing up in the African bush has been an amazing journey for me. As a young boy, my fascination with all things wild meant I spent many hours observing wild animals and their habits. Sometimes my pursuits were made to find a particular animal to harvest for the pot, and sometimes just to learn about an animal as it went about its day-to-day business. The concept of tracking animals became "academic" only in my later years as, in my youth, I took it for granted that this was a completely natural skill, possessed by everyone.

Tracking is no exact science. There are differences in both skill and skill level between trackers. When you're with someone else in the bush, you soon realize how his or her tracking skills compare with your own. There is seldom a competitive attitude between guides, but rather an admiration and respect for those who are much better at it than the average individual.

To divide tracking components into academic categories is simple, but how these categories interact with each other is more complex. The basic components of tracking are light (the brightness, the angle), soil type (sandy, clay, rocky), ground vegetation (grass density and height, tree cover), the species of animal being followed, scat and spoor—and gut feeling. I know the last is not all that academic, but it's one of the most important aspects needed to make the other parts work. It helps you see the big picture!

Two of the secrets to successful tracking are experience and communication with others who have the same skill. You cannot present a complete story about tracking without referring to the famed San Bushmen of southern Africa. For thousands of years, these unique people have perfected the art of tracking, because their continued existence depended on it.

There are some basic rules when it comes to tracking successfully:

- Wear clothes that are made from a "quiet" material that will not make a noise when you rub past a bush. Also, try to match the garment color to the surrounding vegetation color. (No, it is not necessary to wear complete camo gear!)

- Positively identify the "owner" of the track (what species it is), or you could be on a wild goose chase.

- Never walk on the tracks you are trying to follow, in case you need to go back to get verification on something.

- Whenever possible, track into the sun. This makes it easier to see the track and glean any available information about it.

- Tracking in the early morning and later afternoon gives the track more life and hence some sort of depth. Midday renders the track "flat" and more difficult to identify and follow.

- Have a good knowledge of the animal you are tracking! This is vital to understand where it might be heading—i.e. to water, back to its home range, or to where it prefers to feed. One can learn various details about creatures from their tracks and other signs that they leave behind. In short, do your homework about the game you might encounter, because it will help you with your decision-making.

Tracking is very difficult when done quickly; take your time so you don't overlook any vital information. Focus on the job at hand, so you see all the signs that are in front of you. Sometimes you can be looking intently, but you are looking in the wrong places.

- Looking doesn't necessarily mean seeing! It is always good to have a second look, just in case you have missed a vital clue. What appears obvious may turn out to be a little more complicated.

- Sometimes it is necessary to stand back and look at the "bigger picture." You may be too close to see patterns that might better indicate what the animal is doing.

- Move quietly and be patient. The animal will be startled by any noise, and this will only prolong the search. Find a position that allows you to see the animal without it being aware of your presence—that's the ideal situation.

Additional things good trackers look for:

- Signs of changes in the vegetation around the tracks, such as flattened grass, squashed/damaged leaves, or broken twigs.

- Displaced rocks or logs.

- Other animals that look disturbed by something other than your presence.

- Dew. In the early morning, paying attention to dew will also give you an idea as the whether the animal passed before or after the dewfall.

- Blood. If the track has blood associated with it, it is very important to observe the direction of blood splash. The age of the track can be better estimated by how dry the blood is. (Remember to take into account the humidity of the area at the time of tracking, as this will affect the drying rate.)

- Urine and feces. These both indicate the age of the tracks, and also assist in the overall picture of the task at hand.

- Spiderwebs. Pay attention to those that may have been spun between two trees or bushes that have been broken or disturbed.

Basically, the success of tracking lies in the observation of the tracks and signs that are left behind. Knowing as much as possible about the animals in question, consulting with those who may have more knowledge than you do, and reading about the topic of tracking are all

imperative to being a successful tracker. But, having said that, the most successful and talented trackers are the indigenous people who inhabit Africa—and they do not generally have access to books about tracks and signs. They rely on stories, inherent knowledge, and information passed down from generation to generation. The tracking skills these people have developed over the centuries will always be the basis for our more Western understanding of the science of tracking.

Tracking wild animals takes focus and time, to ensure the optimal results of either locating the animal or reading what the animal's movements have been. Every tracking experience helps improve your technique and can fine-tune your ability to read the tracks and signs more successfully—an amazing learning experience that lasts a lifetime. Sadly, in today's world, these basic tracking skills are needed less and less, as we humans use up more and more land for our cities and malls. Developers bite more aggressively into our wilderness areas every year, trying to satisfy the ever-exploding population.

Further Reading

The Safari Companion: A Guide to Watching African Mammals, by Richard D. Estes.
 Chelsea Green Publishing Company, Post Mills, Vermont: 1993.

Signs of the Wild: A Field Guide to the Spoor and Signs of the Mammals of Southern Africa, by
 Clive Walker. Struik Publishers, Cape Town, South Africa: 1997. www.struik.co.za

Tracks and Signs: A Field Guide to the Tracks and Signs of Southern and Eastern African Wildlife, by
 Chris and Tilda Stuart. Struik Publishers, Cape Town, South Africa: 2000. www.struik.co.za

Wild Ways: Field Guide to the Behaviour of Southern African Mammals, by Peter Apps.
 Struik Publishers, Cape Town, South Africa: 2000. www.struik.co.za

To Jack and Jane Davison
Thank you

ACKNOWLEDGEMENTS

I would like to thank the following people for their involvement in this project:

The gracious people of Africa, for sharing their continent

Humphrey Gumpo, www.humphreygumpo.com

Mark Ivy, Ivy Safaris, www.ivysafaris.com

Dr. Laurie Marker, Cheetah Conservation Fund, www.cheetah.org, and to Santa Friederich
and Patricia Tricorache for help with coordinating the foreword to this book.

Pierre and Margaret Faber of Classic Africa, www.classicafrica.com

Suzanne Ballew of Explorations, www.explorationstvl.com

Bollinger Atelier, bronze foundry, www.bollingeratelier.com

For contribution of wildlife photos: Chuck and Ellen Roach, Cliff Kelly, Denny and Rhonda
Rausch, Rod and Sue Lilly, JoJene Mills, Paul Wheeler, Tami and Justin Young, Jeff Insel

For art photography: Paul Michael Reklaitis, www.prophotoaz.com, and Bob Springate

To Karla Olson of BookStudio, for guidance and direction in the creation of this book

To Barbara Toombs for a terrific manuscript

To Charles McStravick of Artichoke Design for a wonderful design and layout

PHOTO CREDITS

When in the wild, it is not unusual for someone to pick up the nearest camera to capture whatever amazing thing is happening. It is also not unusual for safari participants to share photos as a way to keep the adventure alive. We have done our very best to acknowledge everyone who contributed photos to this book. If we have forgotten you, please accept our sincere apologies and let us know so that we can correct our omission in the next printing.

ART PHOTOGRAPHY

Bill Hewitt: 9
Bob Springate: 19, 24, 35, 38, 46, 71, 114
All other art photography by Paul Michael Reklaitis, www.prophotoaz.com

Fred Krakowiak

Fred Krakowiak, author of *The Artist's Safari* and *Africa: An Artist's Safari*, is recognized as a leading wildlife artist as well as a safari expert. His artwork is commissioned internationally by both private and corporate collectors. He creates vibrant paintings of wildlife from Africa by capturing them in motion and with unique techniques and using mediums such as oil on copper and dye on silk. Blessed with the gift of an artist's eye, he is able to detail every nuance of the animal's existence.

Early on, Krakowiak realized his passion for painting as well as his genuine love for African wildlife. With over 25 years of conventional study in various mediums including watercolor, oil, pen and ink, and dye on silk, Krakowiak's foundation has been his formal training in the ancient art of Sumi (pictures in ink). The fundamentals of Sumi require the artist to learn from mistakes and often omit details. Krakowiak's paintings illustrate that what is missing is as important as what remains. This skill allows viewers to become involved in the painting by filling in the missing details with their imagination and experience the power of action at that exact moment of passion.

Krakowiak's books chronicle his travels in Africa. He was inspired to capture African animals by his awareness that one day his artwork and stories may be all that remain of these majestic creatures. His appreciation and respect for the mysterious beauty of these animals and the land was the motivation for creating his beautiful books. Described as a "feast for the eyes" by the *Virginia Quarterly Review*, *Africa: An Artist's Safari* was the recipient of the prestigious 2008 Ben Franklin Award for large format cover design.

Krakowiak regularly tells stories of his travels and demonstrates his art at zoos and museums across the country. He has exhibited his art and given presentations on his safaris and travels at numerous zoos including the Phoenix Zoo, Hogle Zoo in Salt Lake City, Albuquerque BioPark Zoo, Sacramento Zoo, and Cincinnati Zoo while also appearing at the Tucson's International Wildlife Museum, Bowers Museum of Cultural Art, Safari West Africa, Golf Fore Africa, and others.

For further information or to view Fred's amazing art, go to his Web site at
www.maverickbrushstrokes.com